HAUNTED
ST. PAUL

HAUNTED ST. PAUL

CHAD LEWIS

Haunted America

Published by Haunted America

A Division of The History Press

Charleston, SC 29403

www.historypress.net

All images courtesy of the author or via his research unless otherwise noted.

First published 2010

Manufactured in the United States

ISBN 978.1.59629.933.7

Lewis, Chad.

Haunted St. Paul / Chad Lewis.

p. cm.

ISBN 978-1-59629-933-7

1. Haunted places--Minnesota--St. Paul. 2. Ghosts--Minnesota--St. Paul.

I. Title. II. Title: Haunted Saint Paul.

BF1472.U6L48 2010

133.109776'581--dc22

2010005257

Notice: The information in this book is true and complete to the best of our knowledge. It is offered without guarantee on the part of the author or The History Press. The author and The History Press disclaim all liability in connection with the use of this book.

This book is dedicated to the people of St. Paul, both past and present, whose odd and colorful stories and experiences helped shape St. Paul into the grand city it is today.

CONTENTS

PREFACE

St. Paul is the city of mystery and romance, at least according to my friend Johnny Six-Gun. Being a nearly lifelong resident of the city, he should know, and after reading this book you might just find yourself agreeing with him, too. It takes only one trip to St. Paul to see and feel the living history that acts as the city's foundation, holding together both the people and the buildings in a mutually shared past. Having written several books on haunted places throughout the world, I had never taken the time and energy to focus entirely on one city. With the city of St. Paul standing before me, I began my in-depth paranormal-themed adventure. As you will soon read, my journey transported me back to the early days of the territory. I visited Minnesota's first college. Phantom pigs, gruesome hangings and macabre tragedies all sprung up from the most unlikely places, and I even walked the very same floors on which many of the nation's most dangerous criminals danced the night away.

This book, however, is not meant for reading purposes only; it is also meant to serve as your personal haunted itinerary. All but a few of the places featured in this book are open to the public. This means that the adventure lies both inside and outside of these pages. One of my idols in life is Robert Ripley, the man behind *Ripley's Believe it or Not*. Ripley traveled the world extensively and brought back the strange and unusual for all to view. At a time when travel was prohibitively expensive and too time-consuming for the average person, Ripley provided us with the opportunity to experience the odd through his artifacts and stories. Luckily

for us, travel has improved so much that we can now all become our own modern-day versions of Robert Ripley. I think after reading these tales you will discover, much like Ripley himself discovered, that sometimes the weirdest things are right in your own backyard.

I had a terrifically spooky time pursing the haunted tales of St. Paul. The city came alive to me in the sights and sounds that echoed back to the early days of a struggling territory right up to the bustling Capital City that it is today. Many times during the research I was overwhelmed with emotion as my mind was transported back to the fateful events that changed the lives of all those involved. I learned that if you listen closely enough, you will hear the sounds of the haunted history aching to be discovered. Hopefully this book will, in some small part, change your view of the place that I, too, now call the city of mystery and romance.

Keep an eye out!

ACKNOWLEDGEMENTS

I want to thank the people who took time out of their lives to share their personal encounters with the unknown. Without these accounts, this book would have been very dry. I also want to thank all those who strive to keep the history of these unique places going; you truly bring history to life. Lastly, I need to thank my wife, Nisa Giaquinto, for once again showing me that sometimes remaining stationary allows for greater experiences.

INTRODUCTION
A QUICK HISTORY OF ST. PAUL

PIG'S EYE BEGINNING

Today St. Paul's unique combination of location and history converge to make it one of the most fascinating cities in the Midwest. Originally the area that is now St. Paul was inhabited by several tribes of Native Americans. In 1803, the United States acquired the land that would become Minnesota through the Louisiana Purchase and began trying to push the native people west. In the 1820s and '30s, rogue trappers, Native Americans, traders and bootleggers became the first in what would be a long tradition of colorful characters (a tradition that fortunately continues today). One of those compelling characters was a man named Pierre "Pig's Eye" Parrant, who established his bootlegging business along the Mississippi River. Parrant's moonshine was so popular that the area was affectionately known as Pig's Eye. In 1847, James M. Marsh surveyed the land, and the area was swiftly broken into six-by-six-square-mile sections that were originally referred to as townships. In 1849, an act from legislative assembly of the Territory of Minnesota officially established the "Town of St. Paul." A few years of expanding growth and commerce led to the 1854 change from a town to a more sophisticated "City," a distinction that would stick as the Territory of Minnesota received statehood in 1858. With the Mississippi waters churning past St. Paul, steamboats became an essential part of early commerce. Eventually,

thousands of boats transporting passengers and cargo would help St. Paul become a centralized trading community. In the 1860s, railroads began their rise throughout the state. Soon St. Paul would be buzzing with the sounds of thousands of rail cars chugging along the track.

THE GANGSTER YEARS

The gangster years of St. Paul began in 1900 with the appointment of St. Paul police chief John J. O'Connor. While other cities were depleting their already-stretched resources trying to keep their cities free of unsavory characters, Chief O'Connor was welcoming them with open arms. Word soon spread through the underground that St. Paul was a place in which you could operate without the harassment of the authorities. In fact, for the right price, the police would even provide assistance with any shady activities you might have your hand in. Besides greasing the palms of the police, the criminals also had to abide by the rule of not committing crimes in St. Paul. If a thug wanted to venture to the city of Brainerd and rob its bank (which many did), that was fine, as long as it was outside of St. Paul. This policy ensured that every crook, pickpocket, thief, gambler, brothel owner, bootlegger and bank robber at one time or another spent some time in St. Paul. The infamous bank robber Alvin Karpis stated that if you were looking for a guy that you hadn't seen for a while, you usually thought of two places: prison or St. Paul. Every major crook from John Dillinger to Baby Face Nelson considered St. Paul home at one time or another. Even with the never-ending parade of objectionable people passing through, the city of St. Paul was nearly crime-free. Local newspapers and tourist pamphlets praised the safety of the residents of St. Paul and proudly boasted that the virtue of its women was assured. Eventually, all of the unscrupulous agreements and crooked deals between the gangsters and police had to come to an end. That fateful end came in 1934 with the Federal Bureau of Investigation's large-scale corruption investigation that all but assured the cleanup of St. Paul.

The Recent Years

With the city cleansed of most of the criminals, St. Paul looked to its future. The downtown area started to flourish, and soon tall skyscrapers began dotting the changing landscape. St. Paul had also been a home for immigrants, with a nearly daily influx of Germans, Irish, Norwegians, Poles and Swedes. Beginning in the 1980s, the melting pot of nations expanded to include a new generation of African, Hmong and Latino citizens. Today the Capital City takes great pride in the preservation of its historic buildings and traditions.

AN ILL-FATED LOVE AFFAIR
FOREVER HAUNTS FOREPAUGH'S RESTAURANT

The Irving Park area of St. Paul is littered with Victorian mansions acting as beacons that lure visitors back to a simpler time. Sitting majestically in this historic neighborhood is Forepaugh's mansion. The stunning home proudly stands as a testament to the early days of St. Paul. Upon first glance, the home quickly transports you back to a slower pace of life. Immediately you can imagine life here as it was in the 1800s, where hot days were counterbalanced by lemonade under the shade tree and nights were often spent sipping cocktails while socializing with friends and family. But before you get too comfortable in the past, remember that this was also a time when gossip reigned supreme among the wealthy and prosperous. Even the slightest inkling that everything was not picture-perfect would cause waves of unfounded speculation among the community. Luckily for the Forepaugh family, they had nothing to hide, unless of course you want to get picky and count a passionate love affair, tales of bankruptcy and two grisly suicides as gossip.

This cautionary romance tale began in 1870, when love-struck Joseph Forepaugh began construction on his family's future home. Forepaugh strove to build a mansion that would rival the beauty of his wife, Mary. Mary must have been an extremely stunning woman, because in the end, the new home cost Forepaugh over $10,000. In the seemingly blissful life of Mary and Joseph, money was certainly not an issue. Joseph was part owner in very profitable dry goods wholesale business. At an early age, Forepaugh was described as a master businessman and was held in

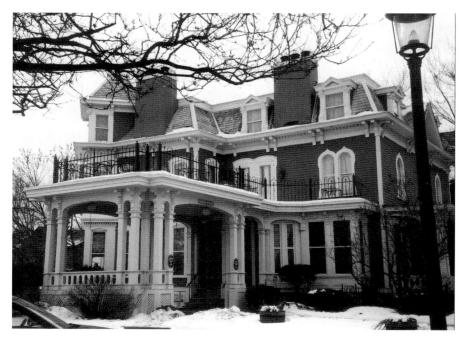

The Forepaugh family estate (now Forepaugh's Restaurant).

high esteem among his contemporaries. Two short years after the main building was built, a carriage house was constructed on the property, and for several years the extended home served its purpose well and the family was comfortable. However, by 1879, the growing family was feeling a bit cramped, so the decision was made to construct another large addition to the home that would give the family a little more room to spread out and relax.

By all external appearances, Forepaugh seemed to have everything a man of his time could want. He operated a very respected and profitable business. He lived in a gorgeous home that was situated in one of the most exclusive areas in the entire Twin Cities, and he had a healthy and loving family. However, all of these things were simply not enough for Forepaugh. Somehow, with all he had attained, completeness still evaded him. Like many others in his vaulted position, Forepaugh believed that what was lacking in his life—and, on a deeper level, in himself—could most certainly be found through an extramarital affair. Legend states that Forepaugh began a heated affair with one of his housekeepers, a woman named Molly. For some time,

An Ill-Fated Love Affair Forever Haunts Forepaugh's Restaurant

Forepaugh and Molly were able to keep their forbidden affair hidden from the prying eyes of others.

Yet during this era, no matter how clandestine you were, concealed secrets were bound to surface. When the scandalous news of the affair finally broke, Forepaugh's wife was furious and forbade her husband from ever seeing Molly again. The loss of his mistress weighed heavily on Forepaugh, who was also riddled with guilt over the entire messy matter. The change in Forepaugh's attitude was instant, and those who knew him best reported that his overall demeanor had been irrevocably changed. Soon Forepaugh found himself plagued with severe bouts of crippling depression. Haunted by a continuous state of twisted thinking, Forepaugh could only conjure up one means of escape: death.

In 1892, Forepaugh had finally been pushed to his mental breaking point, a point in which the solution had already been predetermined. Forepaugh grabbed his loaded pistol, put it to his head and pulled the trigger in the hopes that the bullet would not only end his life but also deliver some needed peace. Forepaugh's lifeless body was soon discovered. Reports state that when he was found his cold hand still gripped the pistol. Immediately, the news of Forepaugh's suicide shook the close-knit neighborhood.

Friends, family members and business associates were at a loss trying to understand the tragic suicide. As a gut reaction, many in the community believed that Forepaugh killed himself over financial matters. They believed that Forepaugh was flat busted, and rather than deal with the embarrassment and shame that poverty would bring to his family, Forepaugh simply chose a different path. Regardless of how juicy this rumor became, it was short-lived. After his death, an inquiry was conducted into the personal finances of Forepaugh, and the findings showed that at the time of his suicide Forepaugh was worth an estimated $500,000, quite a sum of money in the 1800s. Once the matter of money was solved, the speculation quickly turned to love.

Whispers began to circulate that Forepaugh was heartbroken over the termination of his affair and that the only way he could deal with the pain and loss was through the end of a pistol. To make matters even more scintillating, it was said that at the time of Forepaugh's death Molly had become pregnant with his illegitimate child. Perhaps the news that he was going to be a father again pushed Forepaugh over the tipping point toward death. Unfortunately, this rumor would remain a mystery as well, because soon after Forepaugh committed suicide, Molly grabbed a rope and tied it into a noose. Molly then walked up to the third floor and joined her lover in the afterlife.

Some paranormal researchers believe that when tragic events occur, they are forever burned into the very fabric of a location. It appears that this belief rings true in Forepaugh's mansion. After the two suicides, both the mansion and the area fell into disrepair. Eventually the home became so dilapidated that the Housing and Redevelopment Authority had to close it down, and for many years the house remained empty, forever guarding the secrets of its past. Luckily the mansion was purchased in 1974 by the Naegele Restaurant No Limit, Inc., which had plans to resurrect the mansion and to bring it back to its original splendor. The home was painstakingly gutted and completely renovated to be used as a restaurant. It is believed that the construction not only brought the home back to life, it also unleashed its unpleasant history.

Since the first of many renovations, Forepaugh's has been home to many paranormal events. Throughout the years, thousands of guests have visited the historic restaurant to enjoy a delicious meal with friends and family. However, many unsuspecting guests get a bit more than they bargained for. Many tell the story of the home being haunted by Joseph Forepaugh himself. It is while dining that both staff and guests have reported seeing the ghostly image of a man leisurely walking through the restaurant. Witnesses told me that this arrogant-looking man seems to act as though he owns the place. Well, if it is the ghost of Mr. Forepaugh, he does own the place, or at least he did while he was among the living.

Another theory in paranormal research states that tragic events tend to create a haunting. Whether it is an untimely death, a murder, a tragic accident or even a suicide, it increases the chances of the person or place being haunted. Based on this theory, it seems only fitting that the spirit of Molly would continue to roam the mansion even from the grave. Adding Forepaugh's ghost to the equation only enhances the likelihood that Molly's ghost still holds an unearthly attachment to the building. On my first investigation into the bizarre hauntings of Forepaugh's Restaurant, I interviewed several staff members who recalled their frequent encounters with something abnormal.

While working throughout the restaurant, the staff would catch the glimpse of a woman walking by, yet when they turned to get a better look, the woman had somehow vanished into thin air. For years these sightings persisted, and no one spoke of his or her individual sightings for fear of what coworkers might think. It wasn't until customers began to report seeing the vanishing woman that the staff members finally felt comfortable enough to share their own encounters.

An Ill-Fated Love Affair Forever Haunts Forepaugh's Restaurant

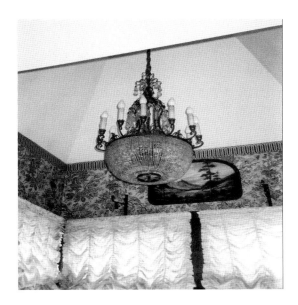

This third-floor chandelier is the area where Molly took her own life at the end of a rope.

What is unusual about the sightings are the similarities that exist among the many various reports. Most people report that the phantom woman looks as though she comes from an earlier time period. The woman is seen dressed in a Victorian outfit as though she lived during the late 1800s or early 1900s. The other detail that sticks out in the mind of witnesses is the near transparency of the woman. Many witnesses were a bit baffled by the fact that they could almost see right through the woman. Those with whom I spoke believe that the strange woman is actually the ghost of young Molly. This odd theory gains some plausibility when you consider that the most haunted spot of Forepaugh's is the third-floor chandelier, the very area where Molly was said to have taken her own life.

Believe it or not, customers can eat at a table that is placed directly under the notorious chandelier. Those who are seated there often report seeing the chandelier sway back and forth as though something is hanging from it. Most of the witnesses are oblivious to the fact that something, or should I say someone, did in fact hang from there. Some witnesses have even gone so far as to report hearing the odd sound of rope creaking from under the chandelier. Of course these guests had no idea that Molly picked out the rope as her preferred method of suicide. In fact, so many odd things have taken place on the third floor that many employees refuse to work alone upstairs at night. Several workers informed me that they would rather be fired than work alone on the third floor.

However, not all of the paranormal activity at Forepaugh's is frightening; it appears that the spirits haunting the restaurant also exhibit a playful side, as well. The haunting at Forepaugh's would not be complete without an assortment of miscellaneous events that, taken on their own, would not cause one to run in terror; however, when they are compiled together with other bizarre happenings, the prospect of being alone at Forepaugh's quickly losses its appeal. I got to talk with a longtime employee who told me that one day she was keeping busy doing her cleaning routine when she stopped at the coat closet to straighten all of the hangers. It only took a few seconds to make sure that all the hangers were equally spaced out from one another. When she finished, she turned around to leave and heard the sounds of the hangers clanging up against one another. When she spun around, she was amazed to discover that all of the hangers had been moved to one side of the closet. Assuming that the spirits wanted the hangers to stay that way, the woman quickly headed off toward a different area of the restaurant.

The spirits also like to play with the restaurant's lighting. On numerous occasions, the lights can be seen turning on and off as though controlled

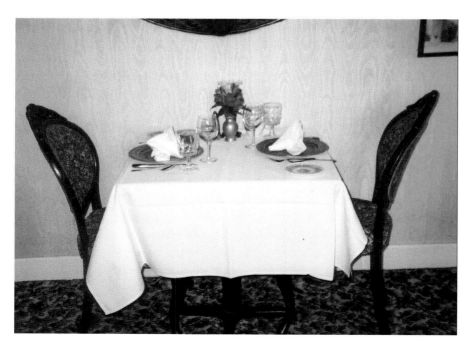

One of the many tables at Forepaugh's, where silverware and plates have been moved by some unseen force.

by something unseen. The story gets even stranger when employees routinely come to work only to discover that the dining chairs have been moved, rearranged and even flipped upside down by some unknown force. Silverware that had been put out the night before a big event also has been found rearranged, almost as if someone had apparently disapproved of their placement and wanted to make sure that everything was in its perfect place.

I also discovered that, like many other haunted places I have investigated, Forepaugh's Restaurant has been home to many unexplained cold spots. Several of the staff reported that while cleaning up at night they would walk into a cold patch of air, the cause of which could never be determined. It happened so frequently that the staff eventually just chalked it up as another bizarre Forepaugh's event and continued on with their jobs. Some paranormal researchers believe that these artificial cold spots indicate the presence of a spirit, while skeptics claim that cold spots are nothing more than our overactive imaginations hard at work. I guess the only way to truly find out is to visit Forepaugh's Restaurant for yourself, and don't forget to ask for the table under the chandelier.

THE HANGING SAILOR OF
MOONSHINE SALOON

Today the Moonshine Saloon is a friendly neighborhood bar and grill on St. Paul's east side. Many of the bar's fresh new customers are gleefully unaware of the gruesome legend lurking in building's dark past. Throughout the years, the bar, like so many other bars, has frequently changed ownership. Each subsequent purchase also fostered a changing of the bar's name. Names like Michael's and Red Mill have adorned the business, but it was when the bar's name changed to the Noose that all the controversy was unleashed. Purchased in 2004 by four friends, the bar's name was changed to the Noose, paying homage to the bar's rumored suicidal history. The original tagline of the Noose bar touted that it was "a great place to hang." For most of those who knew the history of the bar, the name and tagline were thought to be clever and fun. Amid some controversy, the word "out" was added to the end. The Reverend Luches Hamilton, a pastor at St. John's Church of God in Christ, told a local newspaper that he had received some complaints about the name's perceived link to lynching. After speaking to the owners of the bar, the reverend believed that no intentional harm was meant in picking the name. Although some in the community continued to be offended, one had to agree that the controversial name was eerily descriptive of the place's morbid past.

St. Paul records show that the brick two-story Seventh Street building was built in 1889. It is believed that the building has mainly functioned as a bar since its original construction. At times, to supplement the saloon's income, additional space was used as a boardinghouse, renting out rooms to guests

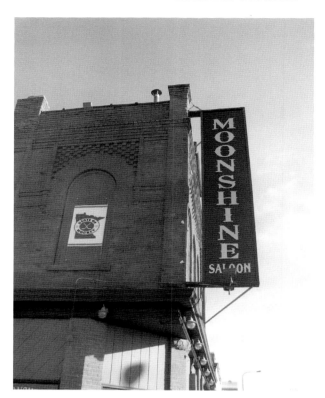

Left: This location is plagued by the spirit of a hanged sailor.

Below: The Moonshine Saloon (formerly the Noose).

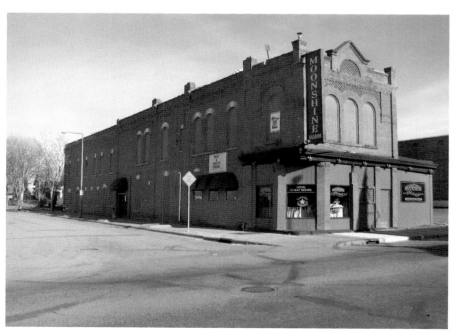

and travelers. It was during the 1940s that a fateful death was rumored to have occurred at the saloon. The prevailing legend tells of a down-on-his-luck sailor who rented out a room at the saloon. For reasons that have either been forgotten or that were never known, the sailor hanged himself inside his rented room. The layout of the building has changed over the years, and the area of the sailor's old room is now thought to be occupied by a bathroom in the rear of the bar. An article in the *St. Paul Pioneer Press* claimed that a young female customer experienced some trouble while inside the restroom. Apparently the woman was alone in the bathroom when the water faucet seemingly turned on by itself. Thinking that the old building simply had some plumbing problems, the woman turned off the running water, only to have it turn on again, this time with both handles.

Former owner of the Noose bar Penny Yauch, who prior to owning the bar had worked there for over ten years, told the *St. Paul Pioneer Press* that her daughter had tried to track down the facts behind the suicide story but was unable to locate the victim's name. Since no evidence of the hanging has yet been located, the identity of the sailor remains hidden in history, though his spirit certainly does not. Longtime employees report multiple encounters with the ghost of the deceased sailor.

In 2005, Yauch told the *St. Paul Pioneer Press* that sightings of the mysterious man were commonplace inside of the bar. Although sightings were not an everyday occurrence, odd things did happen frequently enough for people to casually blame it on the ghost and then proceed with their day as though nothing had happened. Yauch continued, "We have seen things that just shouldn't happen…The guy just keeps hanging around." Yauch stated that the spirit haunting the saloon "picks chairs up and moves them around… and sometimes he knocks things off of the bar." Chairs are by no means the only objects that move on their own inside the haunted saloon. On many nights, witnesses have watched as glasses filled with beer fly across the room and shatter against the wall. When the totality of the saloon's weird experiences are examined, the flying beer stories are somewhat out of place. Stories of flying beer and liquor are fairly common in cases of haunted bars and restaurants, yet if the spirit haunting this establishment is truly that of a stereotypical old sailor, it seems a bit out of character that he would dispose of perfectly fine beer, especially in Minnesota.

A 2006 *St. Paul Pioneer Press* article attributed a laundry list of strange stories to the bar. One of the most interesting happened after the bar had already been closed up for the night. The bartender was alone in the quiet building, where he was quickly trying to finish restocking the bar so that he,

The location of many phantom sailor sightings.

too, could finally go home. In order to avoid the hassle of making another trip to the basement, the man hoisted four cases of beer in his arms and began walking up the stairs. As he walked up the stairs, he mentally devised the best way to open the door with his tied-up hands, and before the man could spring his plan into action, the door unexpectedly sprung open for him. The article also reported the problems that the bar was experiencing with its malfunctioning jukebox. On many occasions, the jukebox would suddenly start playing music on its own. To add to the eeriness of the story, the unaided jukebox would strike up even when it was unplugged. Outside of the jukebox, other inanimate objects exhibited strange behavior, as well. A fancy neon light, which was securely hung near an outlet, began to slowly swing back and forth on its own. Without any pushing or windy drafts, the puzzling swinging of the sign only ceased when the light fell and broke on the floor.

Those who enter the establishment for the first time will often sense the eeriness of the soundings. The saloon itself resembles your typical neighborhood bar—nothing too fancy, nothing too run down. It has a

The Moonshine seating area—for guests brave enough to stick around.

certain charm that I guess comes with having a more-than-one-hundred-year history of serving drinks to the neighborhood. But there is also that nagging feeling of something not quite right that lingers throughout the bar. Even hardened former employees who had witnessed numerous weird things around the saloon remember the place as being nerve racking and often speak of the bar as being downright spooky. The Moonshine Saloon is a place where history continues to live on, and if the frightening experiences of former employees start to dissuade you from visiting the place, just remember that most employees also described the spirit as a very pleasant ghost.

THE BOXING GHOST OF CLYDE MUDGETT

Sometimes while investigating the paranormal, you come across a story in which the background scenario turns out so perfect that you feel that the events surely must have been predetermined by some universal power. Filled with bad luck, good luck, flukes, odd coincidences and chance events, these cases force you to consider the possibility that they may have been predestined. The synchronistic death, and afterlife, of Clyde Mudgett is one such case where it seems fate has left its unmistakable mark.

Blending into the mainly residential neighborhood is the unassuming two-story brick building resting at 940 Beech Street. The building's humble beginnings started in 1883, when it was constructed for use as a meatpackaging plant. From the start the meat business was successful and launched in several growth spurts, as evidenced by these charming early classified ads:

> *April 02, 1892,* St. Paul Daily Globe
> *"DELIVERY MAN—Wanted, a good young man, a rustler. For delivery on meat wagon at once. Call 940 at Beech st."*

> *September 25, 1896,* St. Paul Globe
> *"SAUSAGE MAKER—Wanted, a good sausage maker; German, single man. Call or address 940 Beech St."*

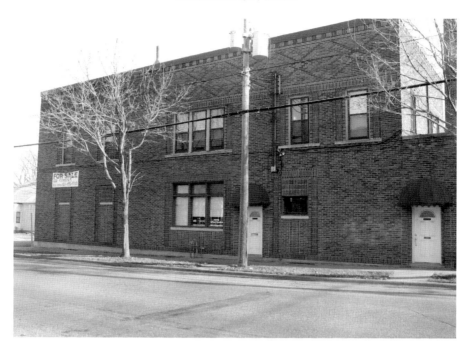

The old Anderson Meat Packing Plant.

For many decades the Anderson Meat Company on Beech Street operated smoothly without suffering any major incidents. That all changed in April 1983 when Clyde Mudgett decided to pay an unwelcome visit to the meat processing plant. At the time, Mudgett was a thirty-year-old professional boxer. As a two-time Indiana Golden Gloves champion, Mudgett had been a promising young prospect in the mid-1970s. Although he was blessed with plenty of natural talent, Mudgett hated training and lacked the self-discipline essential to compete with the elite fighters. Even more troubling, Mudgett also displayed a criminal tendency and all too often found himself on the wrong side of the law. Well known to local police, his crimes eventually led to him to prison. The *Del Rio News-Herald* reported that after serving eighteen months for felony breaking and entering, Mudgett was released from the Indiana State Reformatory. After his release from prison, Mudgett, intent on turning his life around, returned to the life of boxing. In 1977, Mudgett turned pro, a move that only seemed to confirm his desire to live the straight life.

In 1983, an ill-conceived plan would forever alter the fate of Clyde Mudgett. On a seemingly routine Tuesday afternoon, the Anderson Meat Company received an unusual anonymous phone call. The unidentified

caller informed the company that on the previous Sunday an attempted burglary of the building had taken place. The caller also indicated that the burglar might still be on the premises and suggested that the company should check out its chimney. Taking the threat of burglary seriously, the management quickly contacted the police while secretly hoping that the call would turn out to be nothing more than a prank.

Upon arriving, the police discovered a rope attached to the outside of the plant's chimney. When several heavy tugs failed to free up the tension of the rope, the officer summoned the assistance of a fire truck. Investigators concluded that whatever was attached to the rope was preventing it from moving. A plan was hatched to attach the rope to truck's ladder in order to pull up whatever was plugging the chimney. The stress of the truck's tugging eventually snapped the rope, and the men heard something drop down chimney. Authorities had no choice but to bust open the bottom of the chimney, where they came eye to eye with a grisly looking dead body. That "something" that was stuck in the chimney turned out to be the six-foot-one, 190-pound body of Clyde Mudgett.

Authorities began putting together the fragmented pieces of the story and concluded that the death was most likely caused from a burglary gone awry. Mudgett's impractical plan was to lower himself down the Anderson Meat chimney, where once inside he could load up on meat while also searching for cash and other valuables. It was this ill-fated decision that cost Mudgett his life. Mudgett displayed incredible short-sightedness when he grossly underestimated the length of rope needed to descend the chimney by nearly twenty feet. It was believed that while coming to the end of his rope, both literally and figuratively, Mudgett had gotten himself wedged against the confining walls of the blackened chimney. Unable to proceed farther down and powerless to climb back up, Mudgett was hopelessly stuck.

Soon the exiting smoke and toxic fumes traveling up the chimney would have started to sting the eyes of the helpless man. At this point, Mudgett had to have recognized the severity of his predicament. As he savagely struggled for his life, the claustrophobic panic he experienced must have been overwhelming. With each inhalation of the toxic vapors, his lungs must have screamed with agony. Death must have seemed like a welcome release when Mudgett slowly lost consciousness as he chocked on the lethal air. The condition of his body presented the authorities with a gruesome sight. Melva Maldonado of the Ramsey County Medical Examiner's Office told the Associated Press that the body had only been in the chimney for a few days, although the body looked as though it had been completely mummified. The

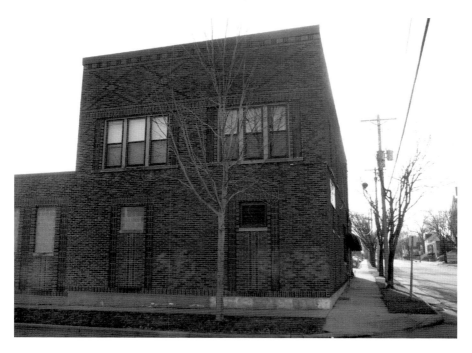

The front of building that once housed Clancy's gym.

heat, combined with the damaging effects of the fumes, created a horrific mess. Mudgett's hands and shoes were also severely worn, casualties from the boxer's last losing fight.

A few people claimed to have inside knowledge that the alleged burglary was merely a clever attempt to cover up the murder of Mudgett. With no substantial proof of foul play to go on, the authorities ruled the case an accidental death. Like so many other morbid tales of St. Paul's past, the macabre story of Clyde Mudgett's death seemed destine to fade from memory—that is, until the arrival of one Jim Glancey. In 1991, Glancey, a retired pipe insulator, discovered that the Anderson Meat Company building was up for sale. As an avid lifelong boxing enthusiast, Glancey deemed that the old meat plant building would be a perfectly suited location for his proposed future gym. Once the purchase was final, Glancey began the arduous task of turning a former meat plant into a functioning boxing center. Transforming the fourteen-thousand-square-foot building was no simple task, and the $50,000 renovation took the better part of a year. In 1992, Glancey opened up his gym to any interested fighters, oblivious to the fact that his newly acquired building already had a boxer, albeit a dead one.

The Boxing Ghost of Clyde Mudgett

Stories of the building being haunted during the life of the meatpacking plant have never surfaced. The tales of ghostly behavior began with the opening of Glancey's Gym. It seems almost too ironic that a meatpacking building where a professional fighter met his dreadful end would eventually be converted into a boxing gym. With such a fortunate coincidence, it almost seems like the story was fabricated for the sole purpose of providing an engaging ghost story. We are all familiar with the overused saying that the truth is always stranger than fiction, but in this case I think the old adage rings true.

During the extensive renovation, Glancey had converted the building's second floor into an apartment, where he lived by himself. After long days of training fighters, he would lock up the gym and retire to his upstairs dwelling. It wasn't long after moving in that the peaceful quiet of his apartment was broken by the sounds of someone hitting the downstairs punching bags. Glancey told a *St. Paul Pioneer Press* reporter that late at night he would hear the sounds of someone battering the punching bags. At first the nocturnal noises provided a real puzzle for Glancey. It wasn't until he learned of the building's deadly past that Glancey was be able to solve the mystery. With the story of Mudgett's death out in the open, Glancey was finally able to put a name to the hard-hitting ghost. Like he did for so many other living fighters, Glancey organized a file on the deceased Mudgett.

The file held a combination of boxing results, fight photos and, most importantly, newspaper clippings describing Mudgett's death. Providing commentary on the fact that while alive Mudgett regularly shied away from intense workouts and favored a somewhat less-than-rigorous regimen—a fact that didn't escape the trainer's keen detective ability—Glancey told the *St. Paul Pioneer Press* that he felt that in death Clyde was making up for all of that wasted gym time. Whatever was behind Clyde's reason, the furious training seemed to be going well, because whenever Glancey went into his bathroom he could hear the double-ended bag rocking back and forth from a constant barrage of punches. On several occasions, the pounding of the bag was so intense that plaster came off Glancey's bathroom ceiling.

In his article "The Ghost of Clyde Mudgett," Mike Mosendale uncovered some interesting happenings at the gym. Mosendale tells that shortly after moving into his apartment Glancey began feeling a strange presence hanging around and often got the feeling that he was not alone. Looking for some rational explanation for the sensation, Glancey began to notice that during the day his place was fine—it was during the later hours of the night that the activity started to manifest. Mosendale also wrote of another odd story

about a phenomenon that is actually quite common in the paranormal field. It happened while a young three-hundred-pound man was off by himself, wrapped up in his training. Suddenly, the sizable young man darted into the next room, frantically asking Glancey if he had just tapped the young man on the shoulder. Glancey assured the young man that he was not responsible for the phantom tapping. The experience frightened the fighter to such a degree that it put an end to his days of training by himself.

A reporter decided to test his nerves and spend the night inside the haunted gym in the hopes of uncovering the source of the moonlight pugilist. For collaboration, or maybe comfort, he also brought along for the adventure a couple of fellow curiosity-seeking colleagues. Together the men littered the gym with some camera equipment. Scattering throughout the building, the men sat quietly in the darkness with their senses on full alert as they waited patiently for the boxing spirit to appear. The span of a couple hours went by and still there was no evidence of any spirits. Growing a bit discouraged, the group found reassurance from Glancey, who reminded them that the majority of the ghostly activity took place later in the evening. After another bout of inactivity, the reporter decided to stretch out and fired off a few jabs on the ghost's favorite punching bag, which was tightly secured to the floor and ceiling. After throwing a few roundhouses, the man walked back out to rejoin his colleagues. Later that evening, while checking on the bag, he was surprised to notice that the bottom bungee had become detached. The reporter was sure that earlier that evening the bag had been properly secured. Even more confusing was the fact that the bag was swaying back and forth on its own. With everyone there pleading innocence, the question of how the mysteriously moving bag became unattached went unsolved.

In 2002, the final round sadly came for Glancey's Gym, and after ten years of fighting, its doors were finally shuttered. Long gone are the days of focused training and competitive matches. Instead, the building is now composed of studios, showrooms, shops and an apartment. What the future holds for Clyde Mudgett's ghost is unclear; maybe he will continue haunting the building with his late-night training, or perhaps with the closing of the gym, he will finally be able to retire.

PHANTOM CREATURES OF THE
MINNESOTA STATE FAIR

G oing to the fair is one of the greatest of American traditions. Long before television, movies and the Internet began producing nonstop entertainment, the fair created a wondrous world of magic, excitement and exhilaration. The fair was miraculously able to capture the perfect combination of kitschy nostalgia mixed with unfettered youth. Fairs of the past were alive with exotic performers, thrilling rides, live animals and more varieties of treats than the imagination could possibly comprehend. The fair provided the ideal place for a family to temporarily forget about the problems of daily life. It was a place where dreams were conceived and fond memories were cast.

Now perhaps I am a bit biased in my fondness for fairs, which can lead to the excessive glorification you just read. Don't get me wrong, I do realize that some of you probably think of the fair as nothing more than an overcrowded livestock show that is accompanied by a heaping side of deep-fried food. Yet the Minnesota State Fair stands far apart from your average run-of-the-mill event. At this fair, scary things are not just lurking inside the haunted mansion, creepiness is not confined to the funhouse and a few of the lively animals housed in the livestock barn are not quite alive.

The Minnesota State Fair began in 1855. During this time, the fair and the state were in their infancies, and for the first few years the fair could not even muster up a permanent home. In the beginning, the fair was held in several different locations throughout Minnesota, and in 1859 the fair was held on the land that has now become downtown Minneapolis. In 1861 and 1862, the

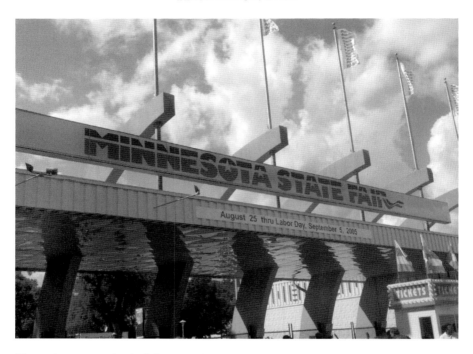

The main entrance for the Minnesota State Fair.

fair experienced its first cancellation due to a divided country engaged in the Civil War. In 1884, fair planners were fed up with the constant changing of the fairgrounds, so a special committee was assigned by the Minnesota State Agricultural Society with the expressed task of locating a permanent location for the fair. The new location was agreed on because it was almost exactly halfway between St. Paul and Minneapolis. In 1885, the fair finally found its home, and the event was held on the spot where the fair is currently located.

For years the fair successfully operated in its new location. In 1893, the fair was once again cancelled. This time a conflict with the World's Columbian Exposition in Chicago put a halt to the event. In 1945, fuel shortages caused by World War II cancelled the annual event. Bad luck seemed to follow the war, and in 1946, the polio epidemic shut down the fair once again. Luckily the fair was able to rebound from the repeated cancellations, and today the fair attracts over 1.5 million visitors each year. In addition to all of the visitors, the fair also attracts a unique variety of ghosts and phantom animals.

Many people venture to the fair just to watch all of the other people. "People watching" is a popular event at the fair, and nearly all walks of Minnesota life are represented on the fairgrounds. Out of the millions of

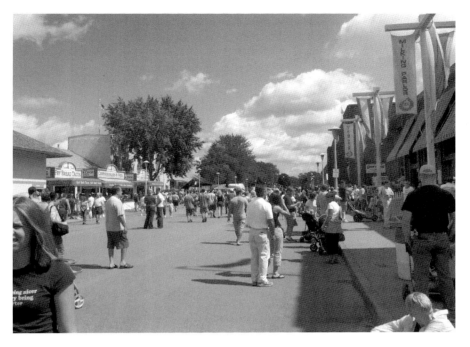

Many fair attendees often report seeing a ghostly image of a man moving through the crowds.

visitors the fair receives each year, a handful of them really tend to stick out. I am referring of course to the ghosts that get spotted walking the fairgrounds. Although these apparitions have been seen throughout the sprawling grounds, the most common sightings of these wandering spirits take place near the grandstand area. The location of the sightings makes sense when you consider that this is the area where all of main entertainers perform. Security guards have on many occasions reported seeing someone mulling about in a restricted area. Thinking that someone had snuck in to get closer to the performers, the guards hurry over to catch the party crashers. But no arrests are ever made—as soon as the security guards arrive, the mysterious trespassers disappear into thin air.

The fair's bandstand area is not the only place where spirits have been spotted. While walking around the fair, dozens of folks over the years have also reported seeing the faint image of someone standing close to them. But when they go to see who it is…you guessed it: no one is there. This phenomenon has repeated itself so many times that both the *St. Paul Pioneer Press* and the *Minneapolis Star Tribune* have published the accounts of the bizarre hauntings of the Minnesota State Fair.

Over the last fifteen years, in my global pursuit of the paranormal, I have investigated thousands of haunted cases. I have come across everything from cursed gravestones and demonic dolls to death-causing apparitions and revenge-seeking spirits. Yet in all my research, this next story ranks up there among the weirdest of the weird. This oddity of a case takes place in the large livestock barns that center as a holding pen for all of the fair's animals. In addition to the various livestock competitions, the fair organizes horse riding events, lectures on animal care and even a petting zoo. On any given day, the fair is overrun with cattle, chickens, ducks, geese, goats, pigeons, pigs, rabbits, sheep, turkeys and even a few llamas.

Yet among all of these healthy, prized animals, the oddest animal is one that is not even alive. Hands down, the weirdest animal inside the livestock barns has to be the phantom pig that haunts the swine barn. That's right, a phantom pig. I have been privy to several accounts of people who, while strolling through the swine barn, have noticed the apparition of a pig inside one of the pens. The bizarre sight is fleeting though, as most witnesses reported that it only lasted a few seconds before the spectral swine

The livestock area that is the home to numerous phantom pig sightings.

disappeared right before their eyes. Legend states that no matter how many times you try, and regardless of the type of camera you use, the phantom pig will not show up in any photographs. And true to the legend, I have yet to see any photographs of the Minnesota State Fair's phantom pig.

Like all the great infomercial hosts say, "But Wait! There's More!" Actually, there is much more, including another paranormal creature lingering around the fair. This case brings us to the reincarnated bird of the Ye Old Mill. The Ye Old Mill is one of the oldest rides at the fair. It consists of old rickety wooden boats that drift slowly through the old mill façade of the building along a slow-moving waterway that winds itself through the building until the ride ends by returning guests outside. In all of its simplicity, the ride is actually quite fun as a throwback to the rides of yesteryear. For many years, the man in charge of dispensing the fun, and tickets, for the ride was Wayne Murray.

By all accounts, Wayne was a true fair worker. Those who knew him said that Wayne took pride in the historic ride and strove to make sure that everyone who passed through the mill enjoyed themselves. Wayne became a well-known character of the fair, and many of his fellow workers were sad to see him pass. But some of his former colleagues believed that Wayne was so devoted to the fair that he even returned from the grave to be there. After Wayne's death, fair season began, and on the very first day of the fair Ye Old Mill was visited by a bizarre black bird. The bird flew over to the ride and perched itself on top of the sign. The bird sat there for nearly an hour before flying off into the sky. Throughout the rest of the fair season, the bird never made another return flight to Ye Old Mill, but its absence would not last long.

After a long Minnesota winter, summer was finally in full gear, which meant that the fair season was close at hand. As Ye Old Mill was opening up on the first day of business, the same black bird flew in and took its spot atop the ride's sign. Again the bird sat there for quite some time before heading off to the sky. For two years in a row, that black bird showed up on opening day, only to remain a stranger for the rest of the season. After a couple more years of the same behavior, employees started to notice the trend of their opening-day friend. Longtime fair workers began saying that the black bird was the reincarnated spirit of Wayne, who was coming back every year to make sure that the ride he loved so dearly was continuing to provide enjoyment for all those waiting to ride it. No matter who or what the bird is, if you want to see it for yourself, you better get to the fair on opening day.

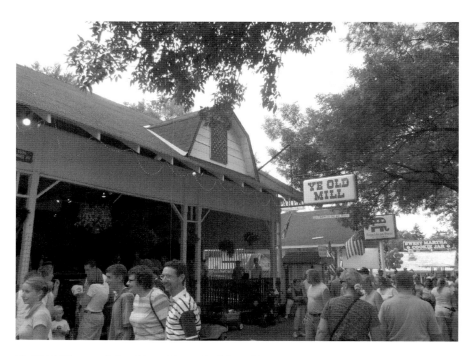

Ye Old Mill, one of the oldest rides at the fair and home to a mysterious ghost bird that appears every year.

Cases like this are interesting because they combine the paranormal with Americana. How often do you get a chance to encounter a mysterious reincarnated bird, trespassing spirits and a phantom pig all while eating a deep-fried Snickers bar? Spirits generally do not exist in a vacuum, sealed off from human contact. They tend to enjoy the same places the living do, and in Minnesota one such place is the state fair.

THE UNKNOWN SPIRIT OF OAKLAND CEMETERY

W hen most people think of haunted locations, cemeteries are one of the first places that spring to mind. The reasoning for this is quite simple. When cemeteries plots were first chosen, the land was believed to be a portal between the living world and the spirit world. Therefore, when a loved one passed away, it would be much easier for the spirit to travel from our living world to whatever afterlife belief dictated. It is truly a comforting idea that cemeteries are merely portals that help guide someone into the afterlife. Yet in St. Paul's historic Oakland Cemetery, many people fear that the newly deceased are not moving into the spirit world, but rather that the spirit world is moving into the world of the living.

The Oakland Cemetery traces its origins to 1853, when a group of St. Paul business leaders expressed shared concern that the city needed a modern nondenominational cemetery for the residents. A forty-acre tract of land was acquired for the newly purposed cemetery. Located about two miles north of the Mississippi River, the tranquil wooded lot served as a perfect place in which someone could spend eternity. Alexander Ramsey, the former territorial governor, would serve as the Oakland Cemetery Association's first president. One of the first goals for the association was to begin the process of platting out the cemetery, and during the next few years the cemetery expanded as additional acres of land were platted.

The cemetery's main design layout came during the 1870s. The park-like layout of the cemetery was a creation of noted Chicago landscape architect Horace Cleveland, who went on to design numerous other parks throughout

The entrance to the historic Oakland Cemetery.

the Twin Cities. In 1905, the cemetery grew in land one final time as another addition was purchased, and the German Lutheran Zion Cemetery was officially included in the Oakland Cemetery. Having expanded several times, the original forty-acre plot had now grown into a sprawling one-hundred-acre cemetery.

Adding to the eerie environment of the cemetery are the numerous old chapels, mausoleums and Gothic statues that dot the cemetery landscape. The first chapel was actually constructed in 1882. Many of the graves were adorned with intricate statues that still seemed to loom over the cemetery with a watchful eye. In 1885, a caretaker's residence was built to provide on-site living quarters for the cemetery staff. In 1892, the first mausoleum was constructed by David Shepard, and a few years later, stables were added to the expanding number of buildings resting on the land. During this time, the cemetery also housed a very profitable on-site greenhouse that sold fresh flowers to both the lot owners and the general public.

Although the cemetery had a great location, early funeral processions often had to battle muddy roads in order to arrive at the grave sites. Finally, in 1869, the city sought to alleviate the transportation problem and built a

A grave site inside the haunted cemetery.

bridge on Rice Street that crossed over Trout Brook. The newly constructed bridge provided a mud-free path to the cemetery. Other bridges and cemetery changes would soon follow, and even the main entrance was moved to its current location on Sycamore Street.

One aspect of the cemetery that I find fascinating is the number of designated areas that are sectioned off for specific segments of the population. These special areas included the "Soldiers Rest," where Civil War veterans were once buried for free. The St. Paul Firemen's Association also purchased a private section of the cemetery specifically for its fallen members. Not to be left out of the purposeful separation, large areas of plots were sold to Chinese, Russian, German and Romanian groups, as well as several other ethnic and social groups. A section of grave sites was even donated to ensure the proper burial for poor residents of Ramsey County, a gesture that saved hundreds from ending up in an unmarked, less-than-dignified mass grave. Together, over fifty thousand people are buried inside the Oakland Cemetery, but it seems that not all of them are eternally resting.

After investigating thousands of cemeteries all over the world, I have found them to generally be straightforward places to research. Normally,

One of the many unique grave markers scattered throughout this historic cemetery.

the cause and legend of the haunting have been well known for quite a few years. Many times, specific dates and names are even attached to the story. For example, in Green Lake, Wisconsin, I investigated a haunted mausoleum at Dartford Cemetery. The legend states that the mausoleum is haunted by the protective spirits of those buried inside of it and that anyone who is brave enough to climb up on top of the mausoleum will be forcefully pushed to the ground by the irritated spirits. With only one mausoleum in the cemetery, I was able to effortlessly investigate the strange legend. Or take the Gypsy Cemetery case I investigated in Algona, Iowa, where the restless spirits of deceased gypsies curse anyone foolish enough to cross over the iron gate that serves as a barrier to the actual graves. For this odd case I was able to locate the alleged gypsy deaths without a hitch. These important details allow for a much more thorough investigation into the cause of the haunted activity.

The Oakland Cemetery case in St. Paul was a little bit more difficult to investigate due to the fact that no specific cause for the strange activity exists.

The Unknown Spirit of Oakland Cemetery

The main legend tells of an apparition of a woman spotted floating through the cemetery. Most of the sightings have taken place at dusk or later in the night. A few reports tell of groups going into the cemetery at night in order to locate the phantom lady. As they wander the cemetery in search of spirits, the visitors see shadows floating across the nearby gravestones. On these bizarre occasions, it is believed that it is the ghostly woman's disembodied shadow that casts a creepy silhouette against the cold stone graves. I have to say that this was one of the more frustrating cases I have investigated. Although I was able to speak with several local residents who were familiar with the ghostly tales of the wandering woman, not one of them knew of someone with a personal sighting. Without knowing the identity of the spirit, the reason for her haunting Oakland Cemetery becomes even more elusive. As I prepared my equipment for my upcoming investigation into the cemetery, the lack of any real details caused me to become a bit disillusioned with this case. I packed up the following items in hopes that their use could shed some light on my case, which was quickly growing dim:

1. EMF meters—A favorite of paranormal researchers; I mainly use these items to pick up any natural electrical or magnetic fluctuations that may be responsible for the weird sightings. Other researchers believe that any significant movement from the EMF meter signifies that a spirit is in the vicinity.

2. Night-vision video recorders—If anything human or nonhuman appears inside the cemetery, these cameras will hopefully pick it up. The night vision allows them to record in low-light situations.

3. Thermoscan—This is basically a laser-guided thermometer that can pick up temperature differences. I had to use it sparingly on this case, as with any outdoor case in which varying temperatures are the norm. Most people are familiar with cold spots being associated with ghosts. This piece of equipment allows you to measure temperature fluctuations in an accurate manner.

4. Motion detectors—Motion detectors come in handy while trying to keep an investigation area clear. If you encounter any curious visitors or prankster, the detectors will usually pick them out. Again you must account for uncontrolled external factors like animals and wind-blown objects that may set off the detectors.

5. Hand-held cameras—I usually bring an assortment of digital and 35mm cameras to an investigation in the hopes of capturing some image of the cause. For many people who are frightened by spirits, the idea of using the camera like a security blanket helps diminish their fears.

6. Audio recorders—Most researchers use audio recorders to pick up any EVPs (Electronic Voice Phenomena)—a voice or sound that is not heard by the human ear that will be audible when the tape is played back. I also really like to have a recorder that functions as a backup notebook on which I can make observations regarding the case. The recorder can also produce an accurate replaying of any witness sightings. However, keep in mind that most people are more comfortable retelling a story when they are not being recorded.

7. Notebooks—Out of all the high-tech equipment that can be used on an investigation, I truly believe that the simple notebook is one of the most essential. Over the years, I have discovered that the functions of a notebook are nearly limitless. Examples of the use of my notebooks include taking notes, measurements, map drawing, recording location markers and building outlines, interviewing witnesses and using as makeshift Ouija boards and even as fire-starters.

8. Assorted gear—This includes a variety of flashlights, computers, cemetery maps, cellphones, tape measurers, plaster, walky-talkies, extra batteries and more.

With all my gear packed and loaded, I arrived at the cemetery a couple of hours before dark to ensure that everything could be set up before darkness settled in around me. Once all of the equipment was ready to go, the anticipation of the investigation started to build. I spent a few hours scouting the areas where previous sightings have occurred, hoping to come face to face with the spirit for myself. As the night progressed, a cold, damp air hovered over the cemetery, producing a sinister chill. Aside from myself, the cemetery was completely devoid of any visitors.

As I patiently waited for the hopeful arrival of the phantom woman, my mind drifted back to the lush warm air of Florida. There, on a similar night, I had staked out an area of Orlando's Greenwood Cemetery, at which nightly spectral figures rise from the grave and wanders around the

cemetery. Even though the locations were 1,500 miles away from each other, what immediately struck me were the overwhelming similarities that the two nights shared. The terrain was different, the weather was different and even the intended targets were different, yet the excited energy of the two places remained nearly identical. I ended up spending a few more hours searching for clues to explain the mysteries of St. Paul's Oakland Cemetery. Although I eventually left that night without a shred of concrete evidence to explain the haunting, I felt that I had gotten one step closer to the mystery of the phantom woman. Perhaps I will never be able to untangle the legend of Oakland Cemetery, but much like my other investigations, I ultimately learned that sometimes the adventure outlasts the mystery.

THE HANGING AND HAUNTING OF ANN BILANSKY

In today's world of capital punishment you rarely hear of an actual hanging. It seems that the process of building a gallows, constructing a noose, hiring an executioner and gathering a strong-stomached crowd is now mostly viewed as an outdated, barbaric tradition. In our search for progress, we have replaced hangings with more empathic forms of sanctioned death. In the twenty-first century the majority of death penalty sentences are administered by lethal injections. In fact, the only states that still permit government hangings are New Hampshire and Washington, and even in these states hangings have not taken place in recent memory.

In the old days, though, hangings were not only legal, but they were also the preferred government method of ending a life. In many towns and cities, both large and small throughout the United States, hangings were viewed as a main source of entertainment and social conditioning. Macabre crowds consisting of thousands of sightseers eagerly showed up to witness the gruesome display of justice. Photos showing groups of well-dressed citizens proudly posed in front of dangling dead bodies were common during that time period a century ago or more. The noose showed no remorse; it welcomed all comers, and it certainly displayed no ambivalence to taking lives. Unfortunately for Ann Bilansky, the act of hanging was not exclusively reserved for men.

Although she is not very well known today, in 1860 Ann Bilansky gained unwelcome notoriety as being the first white woman hanged in Minnesota. Her case began in 1859, when Ann was the fourth wife of Mr. Stanislaus

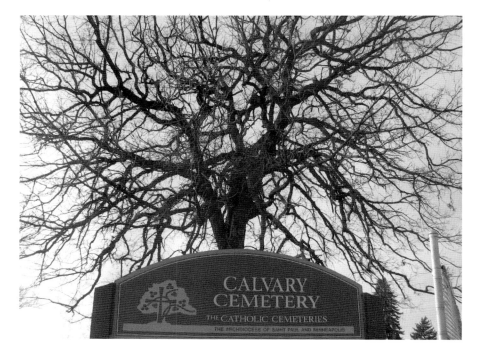

The Calvary Cemetery entrance sign.

Bilansky. Stanislaus was a fifty-two-year-old man who was known to exhibit a fiery temper. Newspapers described Ann as being approximately thirty-five years of age (she was actually forty) and tall in stature, with a sharp visage. She was said to be long featured, with slightly projected front teeth, and many papers reported her to be just a fair-looking woman. The *Racine Daily Journal* took it a bit further with its description and stated, "She is evidently not a handsome woman and therefore may be easily distinguished from womankind generally." Her new husband's three previous marriages had ended in divorce amid claims of physical abuse. Stanislaus's former wives all agreed that he was especially cruel when he was boozed up.

Luckily, Ann would not have to endure the alleged mistreatment for long, as her husband was soon found dead in their home. The official cause of death was ruled to be a stomach ailment. At first glace, nothing seemed out of the ordinary, as Mr. Bilansky had been ill for some time, and the coroner's jury concluded that his death was due to natural causes. However, several people close to the family felt that something was out of the ordinary and suspected that a more devious source had taken the life of Stanislaus Bilansky. It was then revealed that some time prior to her husband's death Ann was

spotted around town purchasing some arsenic. She had told fellow shoppers that she was having some rat troubles and that her husband asked her to pick up some arsenic in order to stop the rats from getting to the basement vegetables. This newly discovered information led to the decision to exhume Bilansky's body so that a postmortem examination could be conducted.

During the investigation, an inconclusive report suggested that some type of crystal was found that held some resemblance to arsenic. Even though the evidence was sketchy, the case against Ann was building, and she and a male friend were quickly arrested and charged with the murder of Mr. Bilansky. Soon the community was rife with the belief that Ann had grown tired of her unsuccessful marriage and had poisoned her husband with arsenic in order to be with her new love. Unfazed by the swirling rumors, Ann stuck to her story and continued to proclaim her innocence.

Regardless of the truth, the cards all seemed stacked against Ann, and it didn't take long for her to be convicted of the crime of poisoning her husband. As she was placed in a St. Paul jail cell, Ann saw an opening for an escape. The *Racine Daily Journal* reported that Ann "quietly walked out one day, and betook herself to unknown parts." Researchers believe that the jailor simply stepped into an attached office for a moment, whereupon Ann ran downstairs and slid her way through the bars of the window to freedom. Ann ran and hid in the shelter of the tall grasses of Lake Como.

Authorities also initially thought that Ann may have been assisted in her great escape, as the *Wisconsin Patriot* wrote that "some of the St. Paul papers charge that her escape is due to the criminal carelessness, if not still more criminal corruption on the part of the jailor." The public was outraged at the escape of such a "dangerous" woman, and to help quell fears the Ramsey County sheriff offered a $500 reward for her arrest. Sheriff Caldwell told the community that when the inmate escaped she was wearing a dark dress with a delicate watch chain and silver watch. The *Janesville Morning Gazette* reported that "suspicions are entertained that she may be in company with a man by the name of Walker, who it is thought, assisted her in escaping." Walker, whose real name was John Walker, was a former boarder of the Bilansky's who had lived in a small shanty in the backyard and was the man initially arrested with Ann.

During her trial, prosecutors alleged that the two had been involved in an extramarital affair. A few days after her escape, Ann and John were captured a few miles away from Lake Como. She had been living in the woods and obtained her food through the assistance of John. The *Manitowoc Pilot* wrote that when Ann was captured "she was attired in male

habiliments." In fact, John had brought Ann the men's clothing and had felt that due to her physical height and looks that she might be better off disguised in men's clothing.

In December 1859, Ann was brought before Judge Palmer to be sentenced for the crime of poisoning her husband. Upon entering the courtroom, the judge asked Ann if she had anything to say about why the sentence of death should not be pronounced upon her. The *Prescott Transcript* wrote that her reply was, "If I die in this case, I die an innocent woman. I don't think I have had a fair and just trial. You can proceed." Judge Palmer then warned her that "she need expect no pardon, and it was useless for her to try to avert her doom—that it was certain her crime had been heinous, and entreating her to make peace with her Creator during the remaining period of her confinement." Various newspapers reported that during this entire time Ann's sobbing was audible for all to hear. The judge then sentenced her to hang at such time the governor may appoint. After receiving her sentence, Ann simply burst into tears.

Any hopes Ann had of escaping the gallows came through the form of public outcries. In 1859, the announcement that the State of Minnesota was going to hang a woman received considerable attention among the general public. Regardless of their feelings toward the guilt or innocence of Ann Bilansky, the majority of the public was not in favor of treating a woman to this indignity. Ann also thought that it might be possible to convince the courts, and the public, that she had not been given a fair and just trial. Newspapers around the country began running editorials against the execution. The *La Crosse Daily Republican* contained the letter from Mrs. Swisshelm, the editor of the *St. Cloud Visitor*, who wrote, "If Mrs. Bilansky is hung, Judge Palmer, Governor Ramsey, the Sheriff, and all aiders and abettors are as much murderers as she can possibly be, and as much deserving of the gallows."

Eventually, Ann's savior came from the State of Minnesota itself. It seemed that the gallows would not end the life of Ann Bilansky after all when the Minnesota legislature passed a bill to have Ann's sentence commuted to life in prison. But Ann's good luck would soon change thanks to the election of Minnesota's second governor, Alexander Ramsey. The new governor would have no part in giving mercy to a ruthless killer, even if she was a woman. On March 16, the governor vetoed the act of the legislature in a final act that sealed Ann's death.

On Friday, March 25, Ann Bilansky was finally escorted toward the gallows. As she walked to her fate, she was surrounded by several jail

The Hanging and Haunting of Ann Bilansky

Governor Ramsey, who signed Bilansky's death order. *Library of Congress.*

officials, clergymen and a couple of gentlemen looking for front-row seats to the hanging. The gallows that had been constructed on the corner of Fifth and Cedar Streets now loomed large in front of Ann. With death looming toward her, Ann took a few short moments to pause and complete a final prayer. Only a few weeks prior to this fateful day, Ann had converted to the Catholic faith, a faith that now held the responsibility of providing her solace as she slowly ascended the steps leading to her death.

Hundreds of onlookers watching from inside the main courtyard were joined by thousands more barely partitioned behind makeshift privacy fences. Standing there dressed in a black dress with a thin brown veil covering her face, Ann requested that her death not be made into a grisly spectacle for all to see. Perhaps the overwhelming sights and sounds of the thousands gathered reinforced to her the absurdity that she would be permitted a private and dignified death. This final realization must have weighed heavily on Ann, as the *Beaver Dam Democrat* reported that her last words were: "Be sure that my face is well covered." With that, the floor dropped, and Ann Bilansky went down as the first woman hanged in Minnesota.

Although Ann's lifeless body dangled from the noose for over twenty minutes, the spirit of Ann would linger for much longer. After the hanging, Ann's body was brought to the Calvary Cemetery in St. Paul. Ann's last-

A monument inside the cemetery.

minute conversion to Catholicism ensured that she would not be denied an eternal resting plot inside the Catholic cemetery. Yet legend states that although the cemetery was forced to bury Ann, its administrators did not want the unsavory notoriety that housing a murderess on their grounds would bring. The cemetery also feared the negative attention that the grave of the first woman hanged in Minnesota would create. To circumvent all of the perceived publicity problems, the cemetery simply buried Ann without a gravestone. Perhaps it was this ill-fated decision, or maybe it was the anger of being wrongly sentenced to death, but whatever the reason, the spirit of Ann Bilansky was not happy. Soon after her burial, the locals began whispering about the vengeful spirit of Ann coming back from the grave to seek revenge on those who had wronged her. On May 26, 1860, the *Racine Daily Journal* ran this story on the strange activity surrounding a spirit believed to be of Ann Bilansky:

The Hanging and Haunting of Ann Bilansky

A ghost in St. Paul—The people of the Third Ward, of St. Paul are in quite a state of excitement in consequence of a ghost which has appeared to sundry and divers individuals recently, at the bewitching hour of midnight. His ghostship is seen on the corner usually near the Park, and steals away noiselessly on being approached, and disappears. It is supposed by some to be Mrs. Bilansky's spirit, as she threatened to haunt the people of St. Paul. Others, pooh-pooh at it, and say it is some one fond of a joke, wrapped in a winding sheet. The people are investigating the subject.

Legend states that the spirit of Ann Bilansky forever walks the cemetery, eternally searching for her gravestone. The lack of a proper burial has caused her spirit to remain restless. In her book *Ghost Stories of Minnesota*, Gina Teel writes that Ann's spirit has been seen roaming the cemetery dressed in a black executioner's robe.

I spoke with several employees and caretakers of Calvary Cemetery who were able to confirm some of the many legends surrounding the death and burial of Ann Bilansky. First, the body of Ann is buried inside the gates of the cemetery; the only problem is that no one is positive of her exact

Grave sites in the cemetery at which Ann's unmarked grave is located.

location. True to the legend, Ann's body was hastily dumped to spend eternity in an unmarked grave. Although the precise location of her grave is unknown, cemetery researchers say that her grave is somewhere in Section 1 of the current graveyard. When our conversation turned to matters of the supernatural, the workers made it clear that as a Catholic cemetery the official response is that spirits and ghosts do not exist—therefore Ann Bilansky does not haunt the cemetery. However, after some gentle prodding, the staff disclosed that over the years stories of Ann's ghost being seen inside the cemetery have circulated, at which point they reiterated the fact that these sightings are nothing more than false rumors.

In my experience with the paranormal, when groups are trying to dispel the haunted stories about a location, secrecy is often the worst course of action. When places refuse to comment on questions and adamantly deny the haunted legends, it only adds to the fires of speculation. For most people, being told to stay away from a place, because there is nothing to see, only increases their desire to discover what is being concealed. In the case of Ann Bilansky, it may be that her body is not the only thing that remains hidden.

THE HIDDEN GHOSTS OF THE LEXINGTON RESTAURANT

In 1935, celebrating the end of Prohibition, Pat and Veronica McLean purchased the neighborhood pub for $2,850. Little is known of the original place that the McLeans purchased. It was said to have dated back to the early 1920s when it functioned mainly as a speakeasy, providing friendly service to most of the general public who chose to disregard that whole Prohibition thing. The McLeans had only one problem with their newly acquired business: it lacked a name. The owners sought to name it after the street on which it resided. Since the building equally rested on both Lexington and Grand Streets, the couple decided to let the flip of a coin decide the name of their establishment. And with that flip, the Lexington was born.

The business was truly a family affair, as Pat's brother, Frank, served as the Lexington's first barkeep. Staff members told me that within a few years the owners bought out the adjoined building that housed a local drugstore. Late-arriving guests would be warmly greeted by the general manager, Don Ryan, an ex-marine, who managed the place for most of his civilian working life. In a time when restaurants usually change ownership every few years, the Lexington stands defiant. In its more than eighty years of existence, the restaurant has had only three owners. In 1990, the McLean family sold the business to Rick Webb, who in 1999 sold the restaurant to its current owner, Tom Scallen. As an attorney and businessman, Scallen also owns the Chanhassen Dinner Theatre, which in a fitting coincidence is also thought to house a couple of spirits.

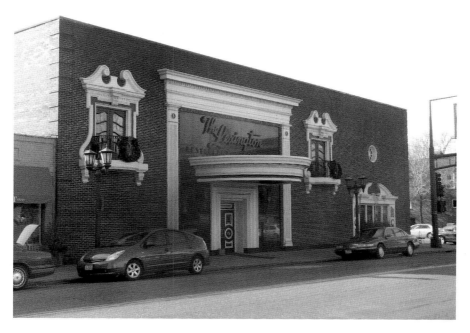

The upscale Lexington Restaurant.

In an unintentional homage to the speakeasy days of the original business, the current staff members have remained tight-lipped about the haunted activities taking place inside the restaurant. One person to come forward with his bizarre experience was author Charles Coulombe, who while writing his book *Haunted Places in America* decided to try out the restaurant's much talked-about cuisine. Unaware of the restaurant's haunted reputation, Coulombe soon learned of the wide variety of paranormal events experienced by the staff. The hesitant staff said that later in the evening, when the rush of guests has died down a bit, you can hear the sound of furniture moving across the floor of the upstairs office. It resembles the sound of someone haphazardly sliding the furniture around while rearranging the office. The sounds are so plainly heard that the intrigued staff have ascended the stairs to discover the noisy culprit, and invariably what they find is an empty office with all the furniture in its proper place.

The staff also report that the anomaly is very erratic and tends to happen in spurts. It was only a few moments after being told of the hauntings that Coulombe and his dining guest heard rattling coming from upstairs. Coulombe wrote that the two men rushed upstairs to find that, this time,

What lies behind the Lexington Restaurant?

the noise was caused by some employees moving a few chairs. When told that the men thought a ghost was in the office, the employees assured the quizzical men that it was just them. They did, however, confirm the previous accounts of the place being haunted by some unknown ghost.

Discouraged by the false alarm, Coulombe and his friend returned to their table and began to question the credibility of the legend. At that very moment, something kicked the rear left leg of Coulombe's chair, which was flush against a wood screen. Convinced that maybe the place was home to some spirits, the men decided to keep their skeptical comments to themselves.

With all of the different types of hauntings out there, restaurant ghosts provide some of the oddest stories, and Minnesota is chock-full of eateries in which the dead still walk. I have investigated hundreds of haunted restaurants, and I am still fascinated by the credibility and sincerity of the witnesses who experience something out of the ordinary while earning their living in this high-stress field. After a long day of dealing with customers who can, at times, be a bit rude, grumpy, dissatisfied and downright mean, the presence of a ghost has to be viewed as an unwelcome addition. Yet maybe the tidal wave of emotions

that accompanies a restaurant actually plays a role in the formation of the haunting.

As I have already mentioned (see also the Fitzgerald Theatre), one paranormal theory ties ghost activity to places with volatile energy. If spirits are indeed attracted or charged by human emotion, restaurants would serve as a spectral jackpot. Ironically, all of this raw emotion also figures into the skeptical explanation of why restaurants are hotbeds for paranormal reports. Skeptics believe that because workers are so worn out and distracted by their endless duties they become more likely to perceive normal events as being paranormal. For example, one of the more common stories I receive from cooks and servers at alleged haunted restaurants involves the disappearance of various items. Staff will often recall putting down an item for just a brief amount of time, only to turn back around to find said item missing. Skeptics claim at these restaurants that things can often get hectic during the crowded rush of mealtime, and the unexplained disappearing plates may simply have been grabbed by another flustered employee behind on their tables. Of course, this reasoning loses some steam when you factor in all of the unexplained accounts from "normal" customers and visitors who are not overly stressed during the sightings.

The Lexington is a very interesting case, and based on whom you happen to speak with, it may or may not be haunted. This is a fairly common problem that researchers face while investigating the paranormal. The duality of the situation is often displayed by the fact that on one day you can talk with an employee who has an endless supply of experiences and haunted stories, while it is just as easy to find another employee that has never even heard of the place being haunted. Nowhere have I found this truer than at the Lexington Restaurant. On my first visit to the upscale eatery, I encountered several servers who confirmed the haunted rumors while busily attending to their guests. However, a follow-up call to the restaurant landed me with a longtime employee who insisted that the ghostly stories were false. The gentleman informed me that he had heard rumblings of the place being haunted, so he decided to do some inquiring. The man casually asked some of the old-time customers, many of whom had been frequenting the Lexington for over fifty years, if they had heard stories of ghosts and spirits haunting the restaurant. Unable to find any such stories, the employee concluded his investigation, convinced that only the living haunted the Lexington.

After much debate, the still question remains: "Is the Lexington really haunted?" As I have proclaimed in the past, the quickest answer comes in

the form of visiting the restaurant for yourself. Regardless of the cause—or in this case, the validity—of the sightings, restaurants with engaging stories of ghosts and spirits provide us with the opportunity to break away from the mundane trappings of big chain restaurants that exhibit zero history and character. Instead, these curious stories remind us that sometimes the weird and unusual are both necessary and rewarding, and after having digested both the marvelous food and ghost stories, you may just leave the Lexington a believer as well…or maybe not.

THE UNELECTED GHOSTS OF THE STATE CAPITOL BUILDING

If you have ever ventured to St. Paul at night, odds are that you have spotted the state capitol building. It is the sprawling white building that is lighted up with so much light you would think it was posing for a postcard photo. In an era when everyone is making deliberate cuts to their energy consumption, it might seem irresponsible for the capitol to always be so bright. However, once you hear all the ghostly tales of the capitol, you will personally understand why they always leave the lights on.

Today's capitol building is actually the third building to house the government of Minnesota. In 1853, the original state headquarters building was constructed on Tenth and Cedar Streets. For many years, the building had successfully met the needs of Minnesota. In 1881, like countless other buildings of the time, the capitol was tragically destroyed by fire. Eager to avoid a similar future fate, it was decided that a new capitol constructed with red brick would be built on the same land that the building occupied. While the government had wisely protected the new building from the ravages of fire, it had failed to foresee the ever-quickening expansion of the state.

From the very start, the capitol building was deemed by many to be simply too small and cramped. Critics of the capitol building proposed that the rapidly growing State of Minnesota needed a grand building that would reflect Minnesota's new stature among its fellow states. The complaints did not fall on deaf ears, and only ten short years after the rebuilding of the capitol, the legislative committee called for the construction of a new capitol structure. In 1893, funds were designated for the new capitol, and

The Minnesota state capitol building.

architectural firms from all over the country competed for the opportunity to design and create the state's new capitol building.

The location of a place called Wabasha Hill severed as the site for the submissions. Over forty separate entries were considered, and in the end the proposal of local architect Cass Gilbert was chosen. Although Gilbert was just thirty-five years of age, he had already established himself as a semiprominent figure in the architectural field. Of course, it certainly didn't hurt that Gilbert was well connected to many powerful players in St. Paul. Gilbert fought for the use of the beautiful, and expensive, Georgia marble that would eventually compose the building's upper walls and trademark dome.

Gilbert also designed the capitol building to be ahead of its time. With the addition of telephones, an advanced heating plant, modern elegant furniture and electric lighting, the capitol was truly state-of-the-art. Of course, with all of these latest conveniences, there came a price. When the expenses of all of the design, labor, building materials, furniture and decorations were compiled the total cost exceeded $4 million. To put the costs into perspective, today the capitol building would take nearly $100 million to construct.

The Unelected Ghosts of the State Capitol Building

On January 2, 1905, after nearly twelve long years of planning, designing and construction, the capitol building celebrated its grand opening. Thousands of curious Minnesotans lined up for the opportunity to tour the magnificent new structure. Those who reported on the process believed that Gilbert had poured his heart and soul into the creation of the structure. With the extraordinary effort and pride that Gilbert exhibited in the creation of the capitol building, it comes as no surprise that many believe his spirit continues to reside inside his architectural masterpiece.

In her book *Ghost Stories of Minnesota*, Gina Tell writes of witnesses who have encountered the apparition of a curious-looking man whose eyes appear transfixed on the structural features of the building. One noticeable feature of the spirit is the peculiar manner in which he is dressed. Often seen wearing immaculate Edwardian clothing, complete with a perfectly placed top hat reminiscent of the early 1900s, the inspecting ghostly gentleman is believed to be the spirit of Cass Gilbert. Having died in 1934, it is theorized that Gilbert's spirit is not merely wandering aimlessly through the building but instead constantly monitoring and admiring the condition of the building he so dearly loved.

Another of the resident ghosts lurking around the capitol is most often attributed to William Colvill. Colonel Colvill served in the Minnesota Regiment during the Civil War. A tall, strong and fearless leader, Colvill's life took a calamitous turn in the Battle at Gettysburg, where he was injured by enemy fire. Civil War records noted that during his time of fighting, Colvill was struck by three bullets. His wounds were so severe that he had to be transported to a field hospital, where he spent several agonizing months recovering. Eventually, Colvill healed up enough to go home. Equipped with a set of crutches, Colvill set off to St. Paul. His wounds had caused such extensive damage that he was virtually maimed and walked with the aid of a cane for the remainder of his life. Although he was in near constant pain, Colvill was never heard complaining and seemed appreciative that he had survived a battle that took so many of his fellow soldiers.

From 1866 to 1888, Colvill served as the Minnesota attorney general. In 1905, Colvill traveled from his Red Wing farm to the Soldiers Home in Minneapolis.

The next morning, the revered colonel was found dead at the age of seventy-five. His body was buried in Cannon Falls, Minnesota. In honor of his service to the state of Minnesota, a statue of Colvill was erected up on the second floor of the capitol, and those who take the time to look closely often see the faint image of a proud Colonel Colvill standing beside it. It

Second-floor overlook, where spirit sightings are common.

is also in the dim light of the late evening when the spirit of the colonel advances down the hallways in search of something unknown. Perhaps in death the colonel is quietly enjoying the pain-free stroll that was unattainable to him in life.

Indubitably, every haunted location needs to have the prerequisite story of a tragic death or dismemberment that has befallen it, and in this category the capitol does not disappoint. The main legend revolves around a former worker at the capitol who met death from a tumble down the stairs. Many staff members and visitors have noticed a white mist ascending and descending the various capitol staircases. The legend of the clumsy worker has been told over the course of many years, and still no one has been able to discover the name or identity of the spectral stair climber.

Author Michael Norman collected several stories of capitol hauntings for his book *Haunted Homeland*. In it Norman writes of a second-floor employee who experienced something out of the ordinary while working in a former Supreme Court justice's office. The employee had walked into a large attached room to grab a beverage when he noticed a slight movement out of the corner of his eye. When he turned to capture a better view of the object,

The Unelected Ghosts of the State Capitol Building

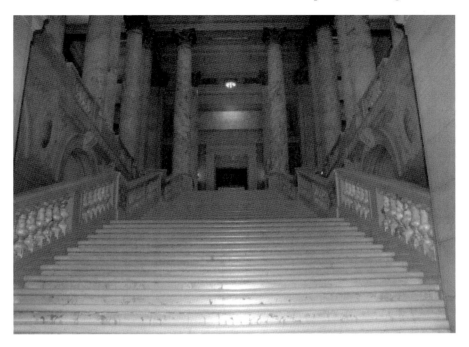

The grand staircase, where spirits are spotted.

he saw a misty form sweep across the room and exit through a main door leading to the hallway. The witness recalled that the misty substance didn't take the form of a human—it was more of a disembodied smoky substance that floated along out the door.

Another capitol legend tells of late-night workers who become increasingly uncomfortable due to the feeling that some unseen person is watching over them. Several employees working late into the evening believe that there is something not quite right lingering in the capitol. Whatever this creepy thing is, the prevailing thought is that for some reason the place takes on an eerie presence once the sun retreats. I spoke with several current employees of the capitol who reported that while strange activity is still occurring, the official capitol stance is to steer the attention away from ghosts and direct it on the history of the building.

The capitol is open for tours and inspection, in which you explore the shadows of the rotunda, chambers and hallways for your own opportunity to encounter distinguished artists, Civil War veterans and other mystifying spirits. With such a wide variety of ghostly activity, the capitol building is guaranteed to remain as scary as the politicians who call it home.

RAMSEY COUNTY COURTHOUSE'S GRUESOME PAST

Outside of judges and lawyers, most people do not consider a trip to the courthouse to be a pleasurable experience. I often get asked the question of why ghosts would want to hang out in such unexciting places. Usually, the question is followed up by the person commenting on the place or places that he/she would haunt if ever presented with the choice. The usual preferred locations include an assortment of bars, sporting events, concerts, restaurants, clubs and even opposite-sex shower rooms. At face value, the question makes a lot of sense. Why would we want to haunt the places that did not hold any interest or significance to us while we were among the living? At first glace, the Ramsey County Courthouse may seem a tranquil and somber place for ghosts to reside, but when you delve into the history of the area prior to the courthouse, you end up with a story more exciting than all of the abovementioned preferred haunting grounds combined—exempting the showers, of course.

Those courthouse employees who like to consume their meals in the downstairs staff lunchroom are often taken back by the sudden ghostly appearance of a man dropping down from the ceiling as if he fell through some sort of invisible trapdoor. The fact that the man is hanging from a noose only adds to the surrealism of the sighting. Even for courthouse employees who witness odd human behavior on a daily basis, this strange sighting stands out above the rest. Throughout the years, the land that the courthouse was built upon has gone though a plethora of uses. Long before the land was home to the courthouse, it was used as a correctional

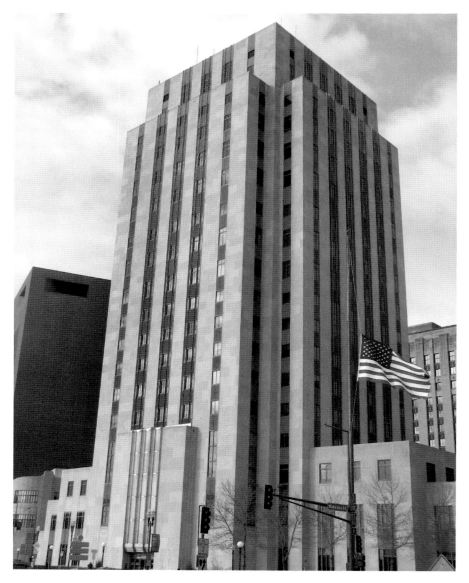

The Ramsey County Courthouse building.

facility containing several jail cells. But for those who are aware of the land's unique history, the odd ceiling event is nothing more than William Williams returning to the last place he knew.

In 1905, a disoriented twenty-seven-year-old William Williams wandered into the police station and brazenly announced that he had shot someone at

number 1 Reid Court. As the gruesome events unfolded, it was discovered that Williams was not just some mad man spouting off crazy remarks. In fact, Williams had just murdered a young boy and his mother in cold blood. Two years prior to the murder, Williams had befriended the teenager Johnny Keller at the hospital at which they both were being treated for diphtheria. The odd friendship took fast and the two quickly became roommates. In 1904, the two even traveled to Canada together, a trip that caught the attention of Keller's father, who believed that his son's friendship with Williams was unhealthy. Knowing that the boy's father was out of the house, Williams showed up at the Keller residence with high hopes that Johnny would accept the invitation to accompany Williams back to Canada. It was an abrupt rejection from Johnny that snapped Williams into a homicidal fit of rage. Johnny was found shot to death in his bed. One bullet had pierced his skull, while another was lodged into the back of his neck. Johnny's mother, F.S. Keller, had also been shot twice but was still alive when authorities arrived at the scene. She was transported to the hospital, where she later died.

During the trial, Williams failed to provide a motive for the killings. Perhaps looking for a lighter sentence, Williams pleaded that he had no recollection of why he killed Johnny. The *Austin Daily Herald* reported that Williams often stated that "Johnny Keller was his best friend and the only friend he had in the world." Instead of an honest account of his crimes, Williams instead told the court that prior to the fateful night he had been awake for three days and finished the third day off by drinking. Williams's refusal to explain his motive only fueled the speculation that Williams and Johnny had been involved in a sexual relationship. The reaction from the community was swift and harsh.

Many newspapers, including the *Eau Claire Weekly Telegram*, described Williams as "a sexual pervert." The jury only needed one hour of deliberation before it brought back a verdict of guilty of murder in the first degree. Before the sentencing was announced, the judge provided Williams with an opportunity to state any reasons why the sentence should not be pronounced upon him. Even through this final chance for comment, Williams remained defiant, and according to the *Eau Claire Weekly Telegram*, all Williams said was, "No. Just as well now. Better now than later on, I guess." The paper continued: "The court then pronounced the sentence that he be taken to the jail and there confined until such time as the governor may fix, after the expiration of two calendar months, when he will be taken to the place of execution and hanged by the neck until dead."

In 1906, Williams prepared for death, as his sentence was soon to be enforced. On February 13, Sheriff Miesen escorted Williams to the basement

of the county jail (now the courthouse lunchroom). A new law dictating the conditions of an execution barred the general public from viewing, and only a few people were permitted to witness the event. As Williams made his way to the gallows, he was guided by Reverend Cushen, whose presence seemed to calm Williams. The *Emmetsburg Democrat* recorded what followed

> *when Sheriff Miesen asked him if he had anything to say a slight tremor passed over his body and he answered: "Gentleman, you are witnessing an illegal hanging. I am accused of killing Johnny Keller. He is the best friend I ever had." The rest of the statement was mumbled and inaudible, and at this point Rev. Cushen stepped forward and pronounced the extreme unction. The hood was then lowered and at a signal the sheriff pulled the lever.*

With release of the trapdoor, the story of the hanging should have ended, but thanks to a gross measuring error Williams simply fell to the floor. The length of rope need for the hanging was inaccurately calculated, allowing Williams a few more precious moments of life. Several of the deputies who were positioned on the scaffold grabbed the rope and pulled it tight; it took just over fourteen minutes for death to take Williams.

With such a bungled hanging, it is no wonder why Williams's ghost is continually repeating the actions that took his life. The details of nearly every sighting are almost identical. The noose-wearing body falls from the ceiling and then disappears into thin air. Researchers like to classify this type of haunted as a "residual" haunting. It is believed that perhaps those viewing a residual haunting are not seeing the actual spirit of someone who has once lived, but instead they are witnessing a playback of an event that has already transpired. To better explain this abstract theory, simply think of the earth as being a sort of video recorder that somehow has the ability to record certain events. When someone comes by on the same wavelength or frequency, the memory, or video, is played back.

Several aspects separate a residual haunting from the others types of proposed hauntings. First, there is never any reported interaction between the spirit and the witness. It seems as though the spirit is not even there, which is quite different to other haunting in which spirits have taken notice of witnesses or have even spoken to them. Another main difference is the repetitive nature of the residual haunting. Time and again, the spirit is seen doing the same thing over and over, as though it were trapped in some undiscovered time loop. Keep in mind that all of these theories to explain away the sighting are nothing more than speculation based on the limited

The hallway in which mysterious footsteps can be heard.

information we possess. With all this being said, the reason behind William Williams haunting the courthouse is still unknown, and unfortunately even though it has been more than one hundred years since Williams's crime was committed, his ghost still refuses to confess.

One of the main legends circulating St. Paul is that the series of underground tunnels beneath the courthouse were once used to illegally transport liquor during Prohibition. The nearly forgotten tunnels were rediscovered in 1999 by men working on the construction of the Minnesota Science Museum. It is said that much of the bootlegged moonshine went to supply the thirsty patrons of Nina Clifford's infamous brothel. This is not a far-fetched claim, as many of the city's most influential movers and shakers spent quality time at Nina's (and the place was never dry). In fact, if you go to the courthouse website, it notes that the legend about the chandelier in the mayor's office coming directly from Nina Clifford's brothel is the most famous unproved courthouse story.

In 1928, Ramsey County was in dire need of a new courthouse. An initiative began that resulted in a public bond offering that raised $4 million for the financing of the new courthouse. Thanks to the stock market crash

A hallway haunted by a well-dressed spirit.

of 1929, the costs of labor-made materials had plunged, thus providing the project with unexpected funds. The additional money allowed the designers to upgrade the project with quality imported woods and twenty different types of marble that would have been otherwise unobtainable. Designed by architects Holabird and Ellerbe, the Art Deco project combined dramatic lighting and a clean sense of lines to create a skyscraper-style courthouse. The courthouse celebrated its grand opening in 1932.

I am unsure if odd things were taking place during the early years of the courthouse. If bizarre occurrences were taking place, they were never recorded. Gina Teel, in her book *Ghost Stories of Minnesota*, tells of a case that was said to have originated in the 1940s. In involves a security guard who, while working the night shift, was approached by a dapper-looking man carrying a suitcase. The stranger's expensive-looking suit gave the guard the impression that he was a lawyer, except for the fact that the man appeared to be thoroughly confused. The cautious guard inquired about the stranger's destination, a question that only seemed to further confuse the man. Without uttering a single word, the stranger turned around and began to leave. After taking only a few steps, the stranger disappeared into a blue mist right before the guard's eyes.

The start of most of the current paranormal activity is usually attributed to the recent courthouse renovations. In 1993, an ambitious $48 million restoration was initiated to preserve the building's historic integrity while simultaneously update the cosmetics. It was during this time that reports of the odd goings-on started to make their way to the general public. Construction workers often complained of tools being moved or misplaced by unknown forces. Pieces of lumber, pipes and other assorted building materials would disappear for days at a time only to reappear in the oddest locations. The normally stoic workers started to complain about someone playing games on the work site. Their work would continuously get interrupted by the sound of someone softly whispering their names.

It is common for the night cleaning workers to hear the sounds of footsteps steadily approaching them only to abruptly stop right in front of them. On many nights, the dim halls of the historic building eerily echo with the distinct sounds of keys jingling about, even though the source for the phantom keys has never been found. The odd spectral sounds haunting the courthouse continue throughout the building when staff members hear the sounds of doors opening and closing on their own. Determined to find the cause of the unusual noises, the workers set off to investigate and are repeatedly baffled to discover that the mysterious opening and closing doors are found locked and secure. Some of the more superstitious night cleaners go out of their way to avoid the War Memorial Hall, where an eerie laughing and a chilling woman's voice have been heard calling out.

The night also ushers in apparitions of dapper men stylishly dressed like they are from the 1930s or '40s. A 2005 *St. Paul Pioneer Press* article noted one such sighting. It was late into the evening when security guard Bill Casebolt was standing near the lobby information when the feeling of being watched crept over him. Seeing as though it was nearly 3:00 a.m., that possibility seemed fairly remote, but just to be sure he glanced over to his right. Standing there at the side of the desk was a man blankly staring at him. The stranger's confused expression was overshadowed by the aura of light that outlined him. The cleanshaven man was dressed in an old gray double-breasted suit coat complete with pleated slacks. The man reminded Casebolt of some lawyer straight out of the 1940s. A bit confused, the guard asked the man if he needed some assistance. No reply came from the bewildered visitor, as Casebolt walked toward him. Perhaps triggered by Casebolt's approach, the man hurried off, walking toward the front entrance doors with some vigor. Casebolt watched as the man slowly vanished right before his eyes. He told the reporter that after

seeing the man disappear, he was certain that he had seen somebody who wasn't really there.

There are some sightings in which the ghosts act and behave like the living, causing confusion among the security officers. The 2005 *Pioneer Press* article included a sighting that seemed so real it resulted in the police being called. It started when security guard Tony Cloutier caught sight of something that zipped up the stairs after being noticed. Not willing to take chances, Cloutier called the police, who upon arriving used a tracking dog to locate the intruder. The dog quickly picked up on the trail that Cloutier outlined. The dog lost the scent on the seventh floor, a floor rumored to house several spirits and a floor that quite of few staff members feel is unfriendly at night.

Out of all the locations in the book, this is the one place that I most dreaded investigating. I had prematurely dismissed the courthouse as just another spacious building that was bound to make a few creaking noises. After discovering that the courthouse was home to hanging murderers, phantom pranksters and a host of other downright unusual activities, I can honestly say that the weirdness of the Ramsey County building has almost succeeded in erasing the unpleasant feeling of entering a courthouse.

THE MYSTERIOUS PERFORMERS AT THE FITZGERALD THEATRE

Weird things are afoot at the historic Fitzgerald Theatre, and I am not referring to Garrison Keillor and the immensely popular radio show *A Prairie Home Companion*, which is taped there. I am referring to weird things of a more ghostly nature. But to understand the theatre's current paranormal activity, we must first understand the history causing it. Today, the Fitzgerald Theatre is a nationally known mainstay in St. Paul, but things were not always so glamorous for the 110-year-old theatre. In 1910, Lee and J.J. Shubert constructed the theatre as a memorial for their brother, Sam. The brothers designed their new theatre after the world-famous Maxine Elliot Theatre in New York. At the time, nothing like it existed in St. Paul. With sixteen separate dressing rooms, two thousand stage lights and a fully movable stage, the theatre simply had no equal.

At the start, the theatre easily prospered, thanks to a nation enthralled with live performances. Legend states that one of the earliest employees to work at the theatre was a stagehand named Ben. Back in the days of pulleys and sandbags, it was among Ben's many duties to make sure everything was working properly, thus ensuring the safety of the actors, audience and staff. This was a responsibility that Ben did not take lightly. Unfortunately, almost all other details regarding Ben's time at the theatre have been lost to history. How long he worked there, why he left, whether he was married and other intriguing questions have forever been left unanswered. One interesting piece of legend that did survive was the apparent care in which Ben took providing a safe working environment for those under his careful watch.

The historic Fitzgerald Theatre.

This crucial information will play a major role in explaining some of the theatre's current paranormal activity.

For years, theatregoers were treated to many wonderful plays, concerts and various traveling acts that all called the theatre home. One of the more popular regular performers was a woman named Veronica. It was said that Veronica possessed such a beautiful voice that she could send the audience home overloaded with emotion. Like Ben, no further information about Veronica has survived over the years. This lack of history has only deepened the mystery surrounding Veronica and the Fitzgerald. Ben and Veronica were certainly not the only ones to leave the theatre; as the nation focused its attention on "moving pictures," theatres around the country began to suffer.

Like similar theatres around the country, the owners had to finally switch over from live events to the new motion picture films. In the 1930s, the theatre gained a wide reputation for screening foreign films, which led to the theatre being dubbed the "World Theatre." Even with all of the new technology, something had been regrettably lost. The theatre was no longer filled with

the electric energy that only live performances could create. It was no longer filled with employees who did their work with passion and love. Once the live performances died, it was as though the theatre itself died. The theatre slowly entered a downward spiral of neglected repairs, forgotten upgrades and bypassed maintenance. Tragically, all of the wonderful life that was once housed inside the walls of the building had vanished, and for many years after the theatre sat dark and empty, a mere shadow of its former self.

Then in 1980, the abandoned theatre was purchased by Minnesota Public Radio, which had grand hopes of bringing the theatre back from the dead. The station spent the next five years performing a sort of virtual CPR on the theatre through a series of renovation, remodeling and extensive rebuilding. During this time, whispers of the place being haunted began to surface, the beginning of its ghostly reputation. Contractors who had been brought in to complete renovations would put down their tools to attend to something and then come back only find that the tools had somehow been moved. Others would find that their tools would simply go missing for days on end only to reappear in the most bizarre nooks and crannies. Not ones to scare easily, the contractors searched for a rational explanation, which, just like their tools, could not be found. Once word started spreading about the strange goings-on, more people came forward with their own odd experiences. One of the strangest events to take place was the finding of old antiques that had inextricably shown up throughout the theatre. By 1985, the renovations had been complete, and the theatre was reopened to an anxious public.

Armed with a fresh bunch of employees and volunteers, the theatre was once again entertaining the grateful guests. The theatre was alive with vigor and enjoyed a renewed energy from the community. Minnesota Public Radio had succeeded in bringing the theatre back from the dead. However, it seems that by resurrecting the theatre, the group had also unknowingly resurrected some of its former employees, too.

The most commonly reported ghost haunting the theatre is thought to be Ben, the former stagehand from the early 1900s. According to the employees I spoke with, Ben is most often sighted up on the catwalk of the theatre. Witnesses believed that Ben's ghost is backstage checking to make sure all of the equipment is set up right and that no one is in danger.

One evening, a female employee was alone inside the theatre. While doing her work, she saw a misty apparition of a man walking around the theatre. The woman was so spooked that she immediately called her husband and begged him to come and pick her up. Not wanting to risk the chance of coming face to face with the spirit again, the woman anxiously waited for her husband

The backstage walkway where a ghost dubbed "Ben" makes sure everyone is safe.

outside the theatre. What the employee did not realize at the time was that she was by no means alone in her ghost sighting. Many staff members have had an eerily similar experience, when they noticed a shadowy figure pass by them while inside the theatre. For the most part, employees believed that Ben is a harmless, helpful ghost. In fact, the employees have even jokingly given Ben his own timecard so he can punch in while he is working.

Although many witnesses have also seen the spirit of Veronica, she is best known for her phantom singing. On many occasions, the peaceful quiet of the theatre is broken by the lovely sounds of a female voice echoing through the seats. Baffled by the noise, employees have spent long periods of time trying to discover the source of the music. Sometimes, when they approach the stage, the singing abruptly stops, and on other nights, the voice simply moves to another area. Those lucky, or unlucky, enough to actually see Veronica report that she appears to be dressed in clothing from the early 1900s, and although she is thought to be mostly harmless, most witnesses do not stick around long enough to find out.

Theatre people are known for having fun while doing what they love, so it only makes sense that the spirits would want join in on the festivities,

The Mysterious Performers at the Fitzgerald Theatre

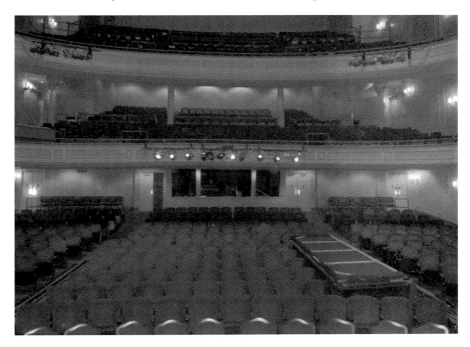

Auditorium in which "Veronica" has been both seen and heard singing beautiful songs.

as well. During my investigation at the Fitzgerald, a worker shared with me a story he could not explain. One day, he was working at the front desk of the theatre when he had to step out of the room for a quick moment. When he returned to his spot, he noticed that his office chair was missing. Perplexed by the fact that he had only been gone for a few seconds, he walked back out to the lobby only to discover that his chair had somehow been moved out there. Now this truly confused the man, because in order for the chair to have moved into the lobby, it would have had to pass right by him.

Researchers believe that, due to several conditions, theatres are a hotbed of anomalous activity. First, most people who participate in the theatre are not in it for the money; they give up their time to the theatre because they have a love for it. It would stand to reason that if people do become ghosts, they would continue to frequent the places that held some significance and provided some comfort to them while they were among the living. Second, it is postulated that spirits are attracted to energy, and perhaps they are even composed of energy. If this is true, then theatres, which are very lively places filled with both excitement and energy, would

make a perfect meeting place for departed souls. The more skeptical observer would argue that theatres are also plum full of props, wardrobes and costumed characters; therefore, any paranormal sightings surely are nothing more than misidentifications on the part of the witnesses. It seems only fitting that these questions, along with many others, play a part in the colorful history that makes the Fitzgerald Theatre so popular.

SPIRITS ABOUND AT THE MOUNDS THEATRE

M any researchers consider the Mounds Theatre one of the most haunted locations in St. Paul, and with three resident ghosts and numerous other visiting spirits, they may just be right. When you first walk into the theatre, you quickly get a sense of the place's history. Built in 1922, the theatre functioned as a live entertainment venue that also showed silent movies. For years, the theatre provided a source of entertainment for the community. During the mid-1920s, the country began to shift its attention to "talkies"—movies with dialogue. This forced many theatres around the country to adapt.

By the early 1930s, silent movies had nearly all been replaced by the new talking pictures. The change in technology forced the Mounds Theatre to make its first renovation in 1933. In 1950, the theatre underwent another transformation, seeking to stay current and profitable. However, like many other theatres around the country, the business end could simply not generate enough income to remain profitable, and in 1967, the theatre was forced to close down. For years, the theatre was nothing more than a storage center for a local antique and junk collector. It sat idle and slowly succumbed to the effects of time and neglect. It is not known if the spirits of the theatre were active during this time. It was not unusual for the place to remain visitor-free for months at a time, so if paranormal activity was taking place, no one would have been there to witness it.

The staff members of the theatre believe that the main cause of the haunted activity can be traced to a handful of spirits that are housed in

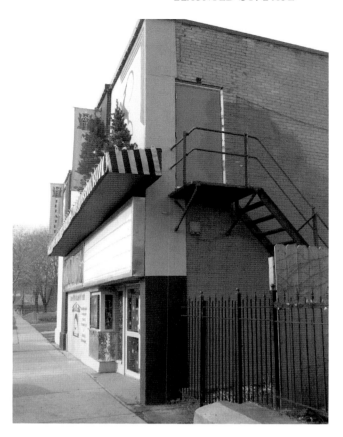

The Mounds Theatre.

the building. The first is thought to be a former employee named Jim (last name withheld by request). Legend states that as a young man Jim gained his employment when the theatre was still in its infancy. It is said that Jim was a large man with a football player's body, so when he applied for a job, the theatre took advantage of his imposing size and gave him the position of usher. In addition to his responsibility of escorting people to their seats, Jim was in charge of providing a quiet and enjoyable environment for the paying customer. If someone was a bit too talkative or rowdy, Jim quieted them down. Of course, it was also Jim's responsibility to politely remove those with multiple infractions.

The legend continues that during this time Jim also began courting a coworker by the name of Mary Anne. Eventually the two fell in love, but regrettably their plans for the future got sidelined when Jim volunteered to be shipped off to the war. Although she was distraught and heartbroken over losing Jim, Mary Anne professed her undying love and promised to

wait for him no matter how long it took. For his part, Jim dutifully wrote her a letter every single week. For three years, Mary Anne's love fueled Jim through the horrors of war. Once the war was over, Jim hurried back to town and anxiously set off for the theatre to surprise his sweetheart. The combination of excitement and nerves filled Jim with dreams of a long future with Mary Anne.

Upon entering the theatre, Jim's dreams were shattered as he spotted Mary Anne sitting in the seats entangled in a romantic embrace with another man, her husband. It is said that Jim never fully recovered from the devastating betrayal and remained alone for the rest of his life. Jim continued to work at the theatre that he now both loved and despised. One can only imagine the pain that was inflicted each time Jim passed by those fateful seats that had forever changed his life.

A faithful employee to the end, it is believed that Jim stayed with the theatre, even after his death. Jim seems to make his presence known throughout the theatre. Many staff members and guests have reported seeing the ghostly presence of a man believed to be Jim walking up and down the theatre aisles. During times when someone gets a bit too loud in the theatre, an audible "Keep it down—ahem—*cough*" can be heard. Others have had their shoulders tapped by the stern spirit. It is believed that Jim is merely continuing his role as usher and politely reminding the offender to adhere to the theatre's social guidelines.

If you happen to venture to the upstairs projectionist booth, you may encounter another of the theatre's resident ghosts. The haunted room can be viewed from the main floor of the building, and on many occasions people have looked up at the room only to see a shadow drift along the window. The ghost's name is Red, and like John he was a former employee of the theatre. Red worked at the theatre as the projectionist. It was Red's job to make sure the films were correctly loaded and that all movies ran smoothly. What makes the Red's spirit so unique is his apparent disregard for sexual harassment. Both staff and visitors report that Red has quite the colorful tongue when younger women are nearby. Psychics who routinely give tours of the place say that Red loves to be in control around women. Red is often described as a crabby old man hellbent on having the last word. He is never said to be evil or vengeful, just simply grumpy.

Perhaps the most active spirit in the theatre is that of a young girl who likes to haunt the aptly named Children's Room. In one of its many community roles, the theatre runs an art program for at-risk children. The large and brightly painted Children's Room provides the children a fun

Left: The stairway to balcony seating and the phantom projectionist.

Below: The interior of the theatre in which several ghosts reside.

and inviting place to foster their artistic abilities. It is a place in which kids can be free to express themselves in their painting, music, photography and many other creative projects. With such a wonderful room, it is not surprising that the young ghost also likes to frequent the area. When the room is empty, the ghost likes to venture in to play. Oftentimes the staff will enter the room after it has been cleaned, only to find that the crayons, toys and papers have been moved around as though someone had been playing with them. Food and drinks are not allowed inside the Children's Room, yet when ghost tours take place, a phantom root beer smell permeates the room. The ghostly aroma drifts around the room and then inexplicably dissipates. The children tell of something touching the hair and gently stroking their heads. No one is certain who this young girl is; her true identity remains hidden in mystery.

With such a wide variety of haunted activities occurring, one has to wonder why the theatre is popular among spirits. I posed that very question to several staff members and volunteers. While I was expecting many differing theories, I was pleasantly surprised when all of them essentially responded exactly the same. Their explanation touted the uniqueness of the place, stating that it was a special place and that there was something almost magical about the theatre. Volunteers immediately fall in love with the place. They even told me about instances where first-time visitors to the theatre became so attached to the place that they had a hard time leaving. I have a sneaking suspicion that the spirits feel the exact same way, too.

THE PHANTOM GANGSTERS OF THE WABASHA STREET CAVES

Although now mostly hidden by time and development, the series of caves indented in the landscape along Wabasha Street played an important role in the lives of many Minnesotans. Unfortunately, due to vandalism and several accidental deaths, many of the caves in the area have been sealed up to be forever forgotten. Yet the Wabasha Street Caves business is still open to the public, and it remains a constant reminder of the place's sordid past.

During the early 1900s, the unique combination of the caves being cool, dark and damp places merged to create the perfect environment for the growth of mushrooms. In fact, the conditions were so suited to mushroom growing that the Wabasha Street Caves soon became the leading producer of mushrooms in the entire United States. The caves were also plentiful with silica, which was swiftly mined out of the caves in order to produce glass needed to help feed the young, booming automobile market.

However, it was during Prohibition that the owners discovered that the expansive caves could also accommodate a whiskey still. Cave number seven was chosen to house the main whiskey still, a decision that would forever alter the fate of the caves. Word about the quality still quickly spread, and soon thirsty citizens from all of the Twin Cities were visiting the caves for a tasty sip of the illegal brew. The place "unofficially" opened and was simply called the Wabasha Street Speakeasy. It served as an underground meeting place at which the public could spend the night eating, dancing, drinking and gambling. It was also the type of place where a man could go to partake

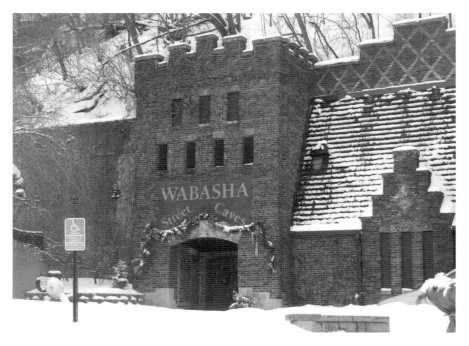

The exterior of Wabasha Street Caves.

in the comfort of one of the "ladies of the night" who made their living working at the speakeasy.

Of course, while the speakeasy gladly catered to the inhibitions of the community, it also opened the door for many unsavory characters to wander in. During this era, St. Paul was a safe haven for many of the nation's most infamous gangsters and crooks. The caves were favorite nighttime hangouts for noted criminals like George "Baby Face" Nelson, Alvin "Creepy" Karpis, Homer Van Meter, the deadly Barker-Karpis Gang and a plethora of other dangerous characters. It was at the caves where a young lady attending a dance got a little closer to danger than she could have ever intended. Legend states that it happened in the early 1930s, when the caves were still an illegal operation.

The speakeasy often hired big bands to entertain its clientele, and one evening a young woman was listening to the wonderful sounds of the band when a stranger approached her and asked for a dance. Given that this was the 1930s, the woman normally would not have accepted an invitation to dance from a complete stranger, but there was something about this man's glowing confidence that really intrigued her. After some thought, she

hesitantly agreed to a dance, and when they were finished dancing, the man left with several of his buddies. Immediately several of her friends rushed over to her side and said, "Do you know who were just dancing with?" A bit confused by all of the attention, the young woman replied, "No, but I wished he would have stayed, because he was a great dancer." The woman's excitement climbed even higher when she was told that her mysterious dance partner was the most wanted man in the world—John Dillinger.

Once it was certain that Prohibition was coming to an end, the cave's owners, William and Josie Lehmann, set about transforming the place into a legal nightclub, and in 1933 the Castle Royal nightclub officially opened its doors. Even though the establishment was now legal in the eyes of the law, the place could not shake some of its shady clientele. These underworld men ensured that the former speakeasy often reared its dark and deadly side. In 1934, four of the club's patrons were gathered around a table, involved in a heated game of poker. It was late at night, and the cleaning woman thought it was weird that all of the men had music cases with them, even though none of them played in a band. As the woman was tending to her duties, she heard the sound of machine gun fire blasting through the caves. When she ran back to see what had transpired, she was horrified to discover that three of the men had been mowed down, while the fourth man was perfectly fine. She immediately called for the St. Paul police, who arrived and took control of the situation.

The police told the shaken woman not to worry—they would take care of everything. The police got right to work on the crime scene, and after about an hour had passed, the police called the woman back to the area of the alleged murders. The woman expected the police to ask her what had happened, but instead she was threatened with a harsh warning for playing games and wasting their valuable time. Looking around, the woman was shocked to discover that the place was completely spotless; the police had cleaned up the entire area. The official police response was that nothing had happened—it was all in the imagination of the overworked woman. The woman distinctly recalled that the bloody bodies of the three dead men were not taken from the caves that day; instead, the employee believed the bodies were buried somewhere deep into the back of the caves.

Although everyone knew the St. Paul police were corrupt, no one believed this young woman's story, except for the fact that she had physical proof: above the fireplace, a series of bullet holes from the gunfire were cut into the stone. To this day, the stray bullet holes can still be seen above the fireplace, serving as a constant reminder of the caves' deadly secrets.

Stray bullet holes from a deadly card game can still be seen above the old fireplace.

In the 1970s, disco fever was sweeping through the United States. The Casino Royal nightclub had fallen victim to the trend and hosted many disco music–laced parties. One evening, while closing up after a long night of business, the manager and an employee spotted a strange man walk right by them. Certain that no one could have gotten into the locked-up establishment, the two baffled men carefully watched the stranger as he walked right into a cave wall and disappeared. To make matters even more confusing, the witnesses stated that the mysterious visitor was dressed like a gangster from the 1920s. The two men were unable to account for what had transpired and thought that maybe they were losing their minds. However, the two men could take solace in the fact that when it came to seeing phantom gangsters lingering inside the caves, they were certainly not alone.

One day, the owners were inside the caves with their young son. While his parents were engaged in various cleaning and maintenance duties, the boy was aimlessly bouncing a tennis ball around the caves. On one bounce, the ball got away from him and traveled into the men's restroom, finally coming to a stop near the mirror. The energetic young boy bent down to retrieve the ball, and when he stood back up and gazed into the mirror, he was startled to see a gangster standing right behind him. Confused, the boy twirled around, and much to his amazement, the gangster was nowhere to be found.

Perhaps the most infamous gangster encounter happened during one of the numerous weddings that take place inside the caves. Due to the elegant

The Phantom Gangsters of the Wabasha Street Caves

The men's restroom in which the spectral sounds of music have been heard.

beauty and colorful history of the place, many love-struck couples decide to hold their ceremonies inside the naturally cooled walls of the caves. On one such occasion, a large wedding party was winding down toward the end of the reception. As guests were starting to depart, one young boy commented that he really enjoyed playing with all of the funny gangsters who were at the party. The members of the wedding party thought that the boy, like most other boys his age, simply had a good imagination and had made up the story to help pass the time. A few days later, while looking through the developed wedding photos, the newlyweds discovered that one of the photos showed a strange mist hovering near the young boy. Convinced that the mist was evidence of the phantom gangster, the couple sent the photo back to the caves, where curious visitors today can still view it and come to their own conclusion as to whether phantom gangsters still enjoy a night out at the caves.

It should be noted that more than just phantom gangsters are reported to roam the inner tunnels of the street caves. One spirit in particular seems to have a mischievous side, as many staff members report that while working in the back section of the caves they will often hear their name being called out, yet when they attempt to respond, no one can be found.

A walkway tunnel to one of the many haunted caves.

Other staff members talk of being pushed or pinched by some unseen force while wandering through the caves. Both the employees and tour goers have caught a glimpse of strange glowing globes of light floating through the bar area of caves. These small orbs can be spotted changing in both color and size, and many of the unknown lights have appeared in the pictures taken of the caves.

The versatile caves have also been home to several theatrical plays throughout the years. It is during these high-usage times that the paranormal activity appears to blossom. During several different productions, actors immersed in rehearsals have looked off stage and spotted the faint image of a busboy casually leaning on the side of a table, as though he was taking a quick rest while enjoying the show. Yet without fail, the phantom busboy is almost always reported to disappear into thin air. On another night, a group of seven actors were up onstage with the director performing a scene from their upcoming performance. Although the caves were completely empty, the group swore that they saw a ghostly image of a man sitting at a table reserved for the audience. It was never determined whom or what this phantom critic was.

The Phantom Gangsters of the Wabasha Street Caves

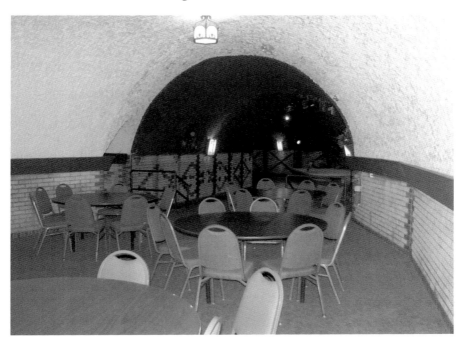

The dining area, where many unknown apparitions have appeared.

Adding even more mystery to the already spooky caves are the numerous stories coming from those taking the historic caves tour—people who report getting more entertainment than they paid for. Some lucky (or unlucky) visitors taking the guided tour have split off from the main group, either to use the restrooms or take a moment to gain a closer look at some of the photos decorating the caves, only to hear the muffled sounds of a 1930s-era big band starting up. At first thought, the visitors think that the tour includes the music of a big band. It is not until they rejoin the group that they realize that there is no band playing that day and that the beautiful music they heard was not provided on the tour. The spectral sounds have been heard drifting through the caves by so many people that they are thought to be some ghostly remnants of the big-band musicians who used to play the night away back in the heyday of the caves.

Of course, no haunted case would be complete without the eyewitness accounts of psychics. As with any tourist location that attracts loads of people, some of them are going to be intuitives, or mediums. Every once in a while, an unsuspecting medium will show up for a cave tour without knowing anything about the haunted reputation of the place. Inevitably,

The main stage on which many of the most famous big bands played.

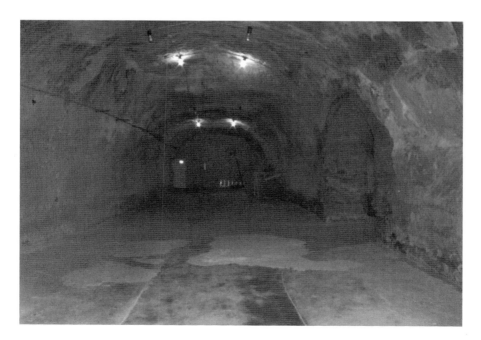

The darkened entrance to the caves.

these mediums end up asking the staff if the place is haunted. One cave toward the end of the tour seems to be a hotbed of paranormal activity. In a relativity small area, many people have seen the spirit of an unknown woman lingering around. During one cave tour, when the group reached the haunted area, a medium who was in the group stated that she was picking up on the restless spirit of a woman in the area. The tour guide then confirmed that the very area they were standing in was the spot where people had not only seen the unknown woman but had also captured her spirit on their cameras.

So what is the cause behind all of the unexplainable activity that occurs at the caves? Could it be that the souls of those men killed in a botched card game still wander the caves seeking eternal peace? Is it possible that the spirit of an unidentified woman haunts curious visitors? Does the music of former big bands still echo in the halls of the caves? The truth is that no one is completely certain why the caves are so haunted. One thing we do know is that if you want to come face to face with the ghosts of fallen gangsters, there is no better place to do it than in St. Paul.

JACK PEIFER AND THE LANDMARK CENTER

Years ago, buildings were constructed with the idea that they would function in the same manner for their entire existence. If a structure was built to design cars, then that is what the building achieved—forever. However, the world today is different: buildings, much like people, often go through several transformations in the course of a lifetime. The Landmark Center in downtown St. Paul is one such example.

In 1902, the building was constructed to serve as the federal courthouse and post office. The building played a critical role in the lives of all who entered it. Inside the walls of the courthouse, the fates of many people were decided on a daily basis. When he started out as a St. Paul bellhop, Jack Peifer could not possibly have foreseen the future impact that the building would eventually have on both his life and his death.

For some time, Jack performed his job duties without incident. As a bellhop, he would often spend his days inside the elevator, assisting visitors and employees. Although he appreciated the work, Jack always believed that he was destined for bigger things. Not content with pushing elevator buttons for important people, Jack knew that the daily grind of a normal occupation did not suit him very well. There are times in every person's life when a decision must be made—a decision that will ultimately change the path that a person maneuvers through in life. For Jack, that ill-fated decision was set in stone when he began running with some of St. Paul's shadiest underworld characters.

During this era, St. Paul was overflowing with bootleggers, brothel owners, gamblers, outlaws, racketeers and plain old thieves. Among these

The Landmark Center.

rough, disreputable characters Jack finally found his calling. Jack quit his bellhop job and focused his energy on working his way up the underworld ladder. Eventually, his hard work and patience paid off, and in 1931 Jack bought part ownership in a popular speakeasy called the Hollyhocks Club. It was at the club where Jack solidified his relationships between both the rich and powerful and the illegal and dangerous. As one of the most popular nightlife spots in the entire twin cities, the Hollyhocks Club attracted a wide spectrum of guests from nearly every social circle. On any given night, Jack could easily shift from talking law with a powerful judge to playing cards with an equally deadly bank robber. While at the Hollyhocks, Jack felt like the world was his for the taking. Yet unbeknownst to Jack, his fate had already been sealed.

During his time at the club, Jack had gained the trust of several gangsters, including members of the deadly Barker-Karpis Gang, which had a well-deserved reputation of being stone-cold killers. When the gang expressed interest in branching out to kidnapping, Jack said he knew the perfect target.

This was the decision that would ultimately bring Jack full circle back to the Landmark building. In 1936, Jack Peifer was ushered from jail to the Landmark building, where in the federal courthouse he was to stand trial for his role in the kidnapping of the Hamm's Brewery heir William Hamm. Not surprisingly, Jack was swiftly convicted on all charges and sentenced to life in prison. Deep in Jack's heart, he knew that prison, much like the normal career he relinquished years ago, was not the life he wanted. While sitting in a county jail cell waiting to be transferred to prison, Jack made a decision that would alter his path one final time. A short time after swallowing a small poison pill, Jack would be dead…but not gone.

During the 1930s, the federal courthouse in St. Paul was the epicenter for the country's war on crime. In addition to Jack Peifer, many of the nation's most infamous criminals were tried inside the walls of the Landmark Center. Billie Frechette (the girlfriend of John Dillinger) created a media frenzy with her compelling trial. In the end, Billie was sentenced to two years in prison on the charge of harboring Public Enemy No. 1. Alvin "Creepy" Karpis was sentenced to life in prison and sent to Alcatraz, while his bank-robbing friend Doc Barker was also found guilty inside the walls of the Landmark Center.

By the end of the 1930s, the crime wave that had enthralled the entire country was finally coming to a grinding halt. With its demise came the first change in the life of the Landmark Center. By the 1960s, the Landmark building was a completely different place—the federal courthouse had relocated, the post office was gone and the building, along with its amazing history, was in danger of being torn down. In the 1970s, a group was formed to stop the demolition of the building. The highly ambitious group initiated a seven-year ordeal that would ultimately restore the building to its original stature. In 1978, the Landmark Center was designated as a National Historic Monument, and it reopened its doors to the general public.

With the makeover, the Landmark Center was given a new opportunity to share its extraordinary history with the general public. From the very start, though, odd things began happening throughout the building. It is widely believed that the main spirit haunting the Landmark Center is that of Jack Peifer. The history of Jack's working-class past comes full circle in the following accounts. One of the nighttime security guards told me that one evening he was making his usual rounds when he approached the third-floor elevators. Much to the man's surprise, the doors sprang open for him, even though he had not touched a single button. The guard believed that the incident was the handiwork of Jack; being a former bellhop, he was just

Above: The courtroom in which Minnesota's most notorious criminals were tried and convicted.

Left: The elevator in which the ghost of Jack Peifer dutifully assists visitors.

continuing to perform the duties of his previous job. The perplexing opening of the elevator is an event that would be repeated for many years and in front of plenty of different witnesses. Two men reported looking down from the third floor into the glass-topped elevator, used by guests with physical disabilities, when they noticed that the rider was wearing an old bellhop's uniform. However, when the elevator reached the third floor, the bellhop was nowhere in sight. The spirit of Jack is not just confined to the elevators, as many visitors have caught a glimpse of a ghostly image of a man walking the halls of the building. Those who have seen the specter swear that it is the ghost of Jack Peifer.

In one of its many functions, the Landmark Center serves as a wonderful venue for hosting weddings. Many couples strive to book the center to celebrate their big night. We are all aware that strange things happen at weddings; from the dollar dance to the hokeypokey, weddings are inherently weird. But stories from Landmark weddings go ever further into the bizarre. During weddings here, guests become puzzled when bottles of liquor appear to fall over seemingly of their own accord. For some undiscovered reason, this only seems to happen to bottles of gin and whiskey. Wedding servers find that shot glasses are often broken with no apparent cause. Peifer's spirit appears to be more active when parties are in full swing, and like a true gangster he displays an attraction to gin and women.

At the front information desk sits an odd wedding photograph. The photo was taken at a previous wedding at the Landmark, and it is thought to show the fuzzy image of a ghost lurking behind the young ring bearer. The *St. Paul Pioneer Press* detailed the anomalous photo story in an article titled "Gangster Still Haunts St. Paul." It was the wedding of Kimberly and Joseph Arrigoni, who like all new married couples wanted to capture as many memories of their wedding as possible. The photographer had assembled the entire wedding party on the center's grand staircase, a favorite photo spot for couples. The picture was just one of many taken that night as the rush of reception activities progressed. No one gave the wedding pictures a second thought until they were developed a few months later.

While flipping through the stack of wedding pictures, the couple noticed something odd about one taken on the staircase. The picture showed a fuzzy image of a man hovering over the shoulder of the five-year-old ring bearer. Neither the husband nor his wife could place who the man was. It seemed rather odd that an unknown man could have posed in the small group photo without anyone noticing. In an effort to discover the mysterious man's identity, the couple asked several friends and family

The women's restroom in which phantom voices can be heard.

members if they recognized him. When no one could say who the man was, the ghost photo was sent to the Landmark Center to be added to its already large haunted file.

Perhaps the creepiest Landmark wedding story came to me from a woman who had attended the ceremony of one of her best friends. Midway through the reception, the woman set off to use the restroom. While washing up, the woman splashed some water on her face in an attempt to cool down from all of her dancing. As she was finishing up, she heard the eerie sound of a strange man laughing directly behind her. When she turned around to see who the laughing man was, she found that the bathroom was completely empty. She told me that the disturbing laugh frightened her so badly that she had trouble walking back to rejoin the wedding.

The woman was much relieved when I told her that, over the years, I have collected dozens of bizarre stories about the women's restroom. She took comfort when I told her that a lot of people have gone into the same empty restroom and reported seeing the stall doors open and slam shut on their

The women's restroom stall that mysteriously slams open and closed on its own.

own. In 2001, Pam Sicard, an events coordinator for the Landmark Center, told the *St. Paul Pioneer Press*, "We have even had women guests here go into the second-floor bathroom and come out quivering, saying that they saw a man in there, a man that disappears. He's a little bit menacing." Could this ghost be the spirit of Jack Peifer coming back from the dead to continue the hell-raising he enjoyed so much in life?

The stories of the Landmark Center, much like the building itself, are full of mystery, intrigue and wonder. As I concluded my research into the richly interesting life of the building and its ghostly inhabitants, I was left with many more questions than answers. As I quietly made my last rounds of the place, the entire impact of the amazing events of American history that had transpired there had still not fully sunk in. As with most things in life, it took a little time and distance for me to process the real story behind the Landmark Center. In the end, all I can hope for is that you get a chance to do the same.

GUESTS WHO REFUSE TO CHECK OUT OF THE ST. PAUL HOTEL

The St. Paul Hotel's history is draped in folklore and intrigue. Today the luxurious hotel joins many of its downtown counterparts as a standing monument to St. Paul's colorful history. If you travel anywhere in the United States, you have an almost endless selection of hotels from which to choose. If you go with one of the big-name chains, you know exactly what is in store for you. From the room's décor to the size and shape of the swimming pool, everything will remind you of the last place in which you stayed. Now imagine if every hotel you stayed in decided to make a checklist of unique reasons for why you should stay with them. In my own world of the strange and offbeat, if the St. Paul Hotel created such a list it would probably look something this:

> *History of gangsters using the hotel for their headquarters* √
> *Former guests staying at hotel to be close to Nina Clifford's legendary brothel* √
> *Reports of ghosts who refuse to leave the building* √
> *Soft beds* √

I threw that last one in there. Essentially, it comes down to this: from phantom gangsters to spectral bellhops, when you stay at the St. Paul Hotel you have absolutely no idea what might actually happen, and that is one amenity that most other hotels cannot list.

Looking at the lavish hotel today, you would never be able to guess that it rose from humble beginnings. In 1856, local entrepreneur John Summers

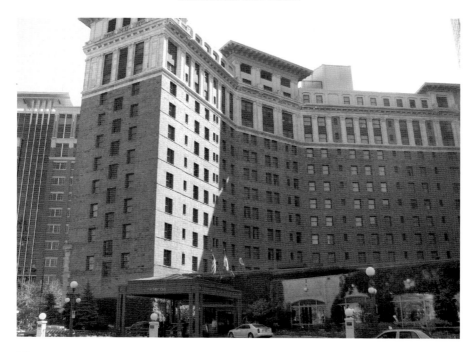

The main entrance of the St. Paul Hotel.

opened his home to weary travelers in need of rest and relaxation. Described as an ambitious man, Summers operated the small-scale hotel while pining over grandiose plans for bigger things. In 1878, a fire burned the home/hotel to the ground, giving Summers just the opportunity to expand that he had desired for so long. Eventually, the hardships of the hotel business took their toll on the once-promising rooming house; in order to survive, it had been mournfully transformed into a theatre and arcade. By this time, Summers had been long gone from the business, yet his dream was at the precipice of fading into oblivion. Before the hotel could die, the property was fortuitously rescued by another ambitious man with his own colossal dreams.

In 1908, Lucius Ordway purchased the property with the intent of creating a luxurious new hotel—one that would have no rival in St. Paul. In 1910, the hotel of Ordway's dreams celebrated its grand opening. Dubbed as "The Million Dollar Hotel," its reputation for extravagance rapidly spread far and wide.

The hotel was an immediate success and routinely attracted prominent and influential guests from throughout the country. Presidents, movie stars, heads of state, royalty, famous musicians and some of the wealthiest people

An early 1900s photo of the hotel's dining room. *St. Paul Hotel.*

in the world have all enjoyed the hotel's hospitality. So how does a hotel with a truly impressive list of past guests become best known for its past association with "the Al Capone of St. Paul"?

Back in the 1920s and '30s, Leon Gleckman was an influential St. Paul bootlegger. In addition to his lucrative moonshine business, Gleckman also had his hands in nearly every other criminal activity that took place in the city. After being released from prison, Gleckman decided that the St. Paul Hotel would be an ideal place to set up his headquarters. Gleckman took over the third floor, turning rooms 301, 302 and 303 into his personal offices. Eventually, the FBI caught wind of Gleckman's living arrangement and rented an adjoining room to conduct surveillance. The FBI didn't have to work too hard, as the hotel lobby was the spot where Gleckman's men collected his weekly payments from St. Paul's illegal businesses. Rest assured that the days of St. Paul gangsters are over (excluding the politicians, of course), but many feel that their spirits still roam the hotel. The outline of a man fitting the description of a 1930s-era gangster has been seen throughout the hotel.

Many high-end businesses would rather not openly promote ghostly activity. The old-school belief is that if the place is deemed to be haunted it will literally scare away potential customers. However, having talked with hundreds of haunted businesses, I can tell you that the contrary is true. Given the extreme popularity of paranormal topics, people actually seek

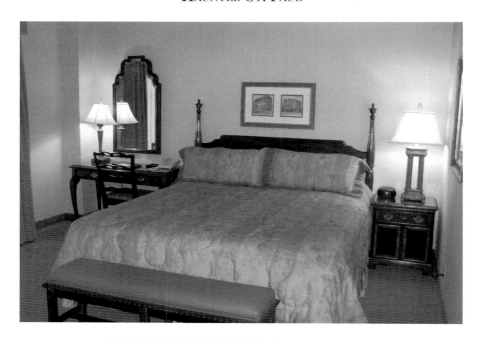

Above: The interior of a guest room once used for a gangster's headquarters.

Left: The rear of the St. Paul Hotel.

out places with haunted reputations. Businesses that promote their haunted stories experience a rush of new guests and customers champing at the bit for a chance to experience the unknown. I was able to speak with several hotel employees, who told me "off the record" and in a clandestine manner that "some pretty interesting things happen here." Following up in a hushed whisper, they expressed a dislike of having to work on the twelfth floor of the hotel due to the strange activity that has transpired there.

One of the hotel's most prevalent haunted legends involves the sighting of a phantom bellhop throughout the hotel. Witnesses take note of the odd manner in which he is dressed. The distinguishing clothing appears to be that of an old bellhop uniform from times long since passed. Guests have noticed that their travel bags have been moved around the room. When I brought up this legend to several employees, I literally received a tight-lipped, affirming response of "uh huh." I was beginning to see that dragging out detailed stories of the hotel's hauntings might be more difficult than I had planned.

Throughout my travels, I had grown accustomed to people's reluctance to speak about their experiences. With my cunning attempts at gathering detailed stories failing, I was forced to change tactics, and for that I turned my attention to the bigwigs. Normally the process works in reverse. I usually begin with the top members of management, who hardly ever agree to give you anything more than a standard, well-rehearsed denial. After the first rejection, I begin to slowly maneuver my way down the corporate ladder until I find someone who is willing to share some details. The details usually come from the everyday staff of cooks, cleaners, receptionists, servers and more. These people are the ones with their figurative ears to the ground—the ones who seem to be aware of the daily goings-on—and are usually all too happy to share their personal experiences with you.

Needless to say, I was more than excited when a bigwig from the St. Paul Hotel promptly returned my call. I guess I should have put "exceptional service" on its checklist as well. However, the manager told me that, while the building is old and does tend to creek a bit, no real stories of hauntings exist. So after my investigation, I was left with conflicting feelings as to whether the hotel was really haunted. On one hand, I had some credible but vague stories from some employees, but I also had just as many other employees who had never heard of such stories. This is one of the more frustrating aspects of paranormal research. The case can take various turns just based on who you talk to. Whether the hotel has ghosts or not is something you will have to ascertain for yourself. At the very least, you will get to spend the night in a terrific hotel filled with history, intrigue and who knows what else.

THE PIONEER SPIRITS OF THE GIBBS MUSEUM

E ven in the modern city of St. Paul, evidence of a simpler time still lurks in a few nearly forgotten places. One such sanctuary of history is the Gibbs Museum of Pioneer Life. The old farmhouse has a twisted tale of loss and heartbreak that could rival any remembrance spun by Laura Ingalls Wilder.

This unusual adventure begins in 1833 with a five-year-old girl named Jane Debow. Jane's mother had fallen ill and Jane was being looked after by the neighbors. Suffering from a detached family life, Jane left her home with Chief Wabasha of the Dakota when he headed for a new life among the prairies of Minnesota. As the years passed, Jane slowly forgot about her previous home in New York and adapted well to her new life in Minnesota. In 1849, Mr. Herman Gibbs began courting Jane, and within no time at all the happy couple was married. With a newly acquired wife to provide for, Herman purchased some land in St. Paul to begin a new life together as a family. Soon, a sod house was formed to provide shelter from the harsh, unwavering weather of Minnesota. For a time, the makeshift dwelling served the family well, but in 1854 the couple decided that an upgrade was in order and constructed a small but functional log cabin.

Over the years, the small cabin slowly grew, along with the size of the Gibbs family. To help make ends meet in trying times, the family ran a small food market on their property, selling food to residents of an expanding nearby town. Farming was a difficult life, and it seemed

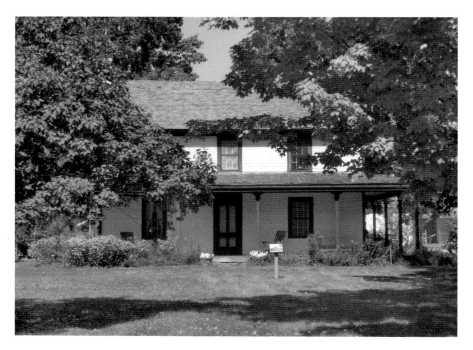

The exterior of the Gibbs Museum.

that tragedy and heartbreak patiently waited for any opening to strike. Unfortunately for many pioneer families, misfortune was never far away. One of the most dangerous elements of the time was fire. The deadly spark of flame posed a constant threat to a family's fields, home and livestock. During prolonged dry spells, the prairies became extremely susceptible to this danger, and the Gibbs farm was no exception. In the middle of a nasty drought, it was only a matter of time until the fields took blaze. As the mighty winds kicked up, the fire was pushed forward until it began threatening the farmhouse.

Every family member fought hard to control the raging fire. The Gibbses' nine-year-old son Willy was among those striving to help put out the blaze. After a long and heroic battle, the family managed to barely save the farmhouse from disaster. While one tragedy was averted, another, more devastating one had crept in. After the fire, Willy took ill from the effects of smoke inhalation, and within a few days their son would be gone. Having become accustomed to sorrow, the family continued on the best they could. Herman passed away in 1891 and was followed by his

wife Jane in 1910. Their daughter, Abbie Gibbs, inherited the property. In 1943, the farm was sold to the University of Minnesota. In 1949, the Ramsey County Historical Society took over the day-to-day operations of the place, and the farm was opened up to the general public and is now known as the Gibbs Museum of Pioneer and Dakotah Life.

Today, the old farmstead functions as a museum of pioneer life that gives visitors an opportunity to travel back in time to gain an understanding of what life was like in the early days of Minnesota. It also keeps the Gibbses' unique history alive for all to view and experience, but for some that experience is a little too scary, because the Gibbs Museum has more than its fair share of haunted activity. For some unknown reason, nearly all of the paranormal activity is centered on the old farmhouse. Most of the other buildings on the property are ghost-free. What makes this case so intriguing is the fact that no one is sure who or what is causing the haunting activities. The peculiar events are so random and varied that a cause cannot be ascertained.

What is known about the spirits is that they seem to like the staff. Many of the tour guides I spoke with expressed an uneasy feeling while leading groups through the farmhouse. Unable to put a finger on the cause of their uneasiness, most simply went out of their way to avoid being alone in the farmhouse. By all accounts, the staff members have good reason to fear the farmhouse when you consider the following events. A female employee was working alone in the kitchen, and as she went about her cleaning she heard the sound of footsteps walking through the hallway behind her. At first, the woman thought nothing of it, but when the mysterious footsteps headed for the stairs, her interest was piqued. Wondering who could have gotten into the house unnoticed, the woman quickly ran up the stairs to see who was there. When it is was discovered that the upstairs was completely empty, the woman ran downstairs as fast as she could.

The kitchen is another hotspot for activity. On several different occasions, staff members have reported that the kitchen's old cupboards will open and close on their own. Even more bizarre are the stories in which cleaning workers have left the room to retrieve something, and when they returned the cupboards that had been previously closed were now all wide open. Even the kitchen door acts up on occasion; it tends to open and close as though it was used by some unseen spirit.

There is some evidence suggesting that the ghost of Willy Gibbs could be haunting the place where he met his untimely death. Over the years, staff members have repeatedly struggled with the toys that are housed in

The museum window at which a disappearing figure has been spotted.

the toy room. Every evening before leaving, volunteers would gather up the dispersed toys from the day's display and put them into a locked chest. When the workers returned in the morning, they found that the toys had been mysteriously removed from the locked box and were back out of the chest. The toys were scattered around as though someone had been playing with them all night. A former tour guide claimed that he was able to sense spirits, and while giving a tour of the house he was able to pick up the spirit of a teenage boy. The guide was unable to determine if the spectral boy was the spirit of Willy Gibbs. It should be noted that not all of the witnesses are believers in the paranormal.

One of the more skeptical guides was enjoying a short break while sitting on the front porch bench that is perched in front of the old farm home. The woman looked back into a window and noticed that a young kid was standing inside the house. Thinking that maybe a kid had accidentally wandered into the closed home, she went to investigate. After searching the entire home, the kid was nowhere to be found. The odd events that take place at the old Gibbs residence are not limited to the museum employees. One

evening, about midnight, a sheriff's deputy was on a normal patrol around the museum making sure that everything was okay. The officer stopped in his tracks when he spotted what he believed was a kid's face peering out of the home's second-story window. When the incident was told to the staff, they informed the deputy that it was impossible for a boy to be in the house, because it was locked up and completely empty. Is it possible that the deputy happened to catch a glimpse of Willy's ghost?

Some of the reports from the museum have to be classified as just downright weird. A former manager of the museum told the story that on many mornings he would be the first person to arrive and open up the farmhouse. Quite frequently, he would find an unexplainable indentation imprinted on one of the antique beds. The outline on the bed looked like someone, or something, had spent the night sleeping on it. The blankets were never used, and the pillows showed no signs of wear either. Needless to say, the phantom squatter was never located.

The farmhouse is designed to fit the period. Filled with many antiques, the museum strives for accuracy when depicting the farm life of the Gibbs. The delicate antiques are used for display only and are off-limits to the

A rocking chair inside the museum that moves on its own.

The museum bed on which an unknown spirit spends the night.

visitors, which makes the abnormal behavior of an old wooden rocking chair that much more baffling. Apparently, museum rules do not apply to those in the afterlife, as noticed by staff members who have walked inside the room where the antique chair is positioned and watched as the chair slowly rocks back and forth even though no one is sitting in it. The chair must be some favorite resting spot for a spirit, because other staff members have walked into the room and also noticed the chair moving even though the room was completely empty.

The Gibbs Museum of Pioneer and Dakotah Life was one of my favorite cases to investigate due to the sheer number and variety of reputable people who had come in contact with the unknown while spending time at the museum. In 2008, I was invited to be the guest speaker at the annual meeting of the museum and historic farmhouse. I was delighted to go back to the museum, since a couple of years had gone by since my first investigation. Surrounded by the dozens of devoted employees and volunteers, I was told that the paranormal activity had not ceased. During

my first investigation, all of the spirits had abided by the museum rules and sadly made no appearance. I had left the museum without so much as an involuntary shudder, but on the on the night of my lecture it only took me a few seconds to see what the employees were talking about. Although I do not possess one ounce of psychic ability, this time the place immediately made an unfavorable impression on me. Maybe it was the overwhelming musty smell that accompanies most museums, or perhaps the antiques succeeded in creating a creepy atmosphere. Whatever the reason, by the end of my talk I more than agreed with the employees' belief that the Gibbs farmhouse is one eerie place.

476 SUMMIT AVENUE

THE GRIGGS MANSION

For weeks I have drifted back and forth on the idea of including the Griggs Mansion in this book. My constant teetering had nothing to do with a lack of haunted stories, as the mansion is thought to be one of the most haunted places in all of St. Paul. My indecision arose after my visit to the mansion, during which I was able to spend some time with the current owner, a lovely senior woman who doesn't believe in, nor likes to dwell on, the home's widely known haunted reputation. Normally I like to write about, and investigate, places that are accessible for people to visit and check out for themselves. For me, adventure plays a significant role in the excitement that these stories create.

I wholeheartedly encourage people to not simply take my word for the haunting activity but to visit these places and decide whether they are haunted. After my conversation with the present Griggs Mansion owner, I knew that would not be currently possible. Finally, two nagging thoughts wore away at my overall hesitation. First, the decades of paranormal activity have produced some extraordinary stories that were simply too interesting to keep hidden any longer. For my second point I had to become a bit of a soothsayer, as I tried to look into the unknown future. I quickly realized that I would make a horrendous psychic, because I have no idea what the future will bring to the Griggs Mansion. In December 2009, the home was placed up for sale on the real estate market. In the future, the mansion could quite possibly be transformed into a historic museum or public space, and if that turned out to be the case, I would

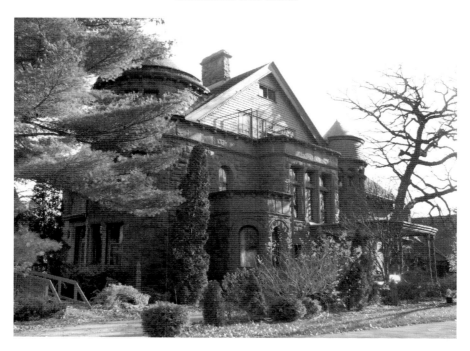

The historic Griggs Mansion.

hate to deprive any future readers from the magnificent experience that is the Griggs Mansion.

The best way to get acquainted with this story is to start at the beginning. In 1883, Chauncey Griggs, a wealthy businessman, wanted to create a home that would reflect his grand station in life. If he truly wanted to be among the elite of the city, he knew that he would have to build on Summit Avenue, a street in an exclusive neighborhood of high social standing. For this master creation he turned to Clarence Johnson, who designed the building in a Richardsonian Romanesque style. Construction on the majestic twenty-four-room sandstone mansion was completed in 1885 at a total cost of $35,000. The results of Johnson's vision most certainly did not disappoint an overly pleased Griggs. However, in only a few short years, the same business that provided the means for the mansion also dragged Griggs away from it—to the fertile business lands of the West. Griggs's early departure created a succession of owners who for reasons untold would similarly exit the home a bit prematurely.

In 1915, a young maid employed at the home was said to have become heartbroken by a failed relationship. Legend states that the "love gone

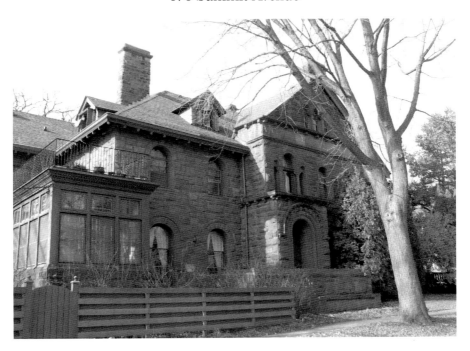

The front of the Griggs Mansion.

wrong" had driven the normally cheerful woman into a manic state of depression. Unable to shake her melancholy, the woman hanged herself on the landing of the building's fourth floor. Her apparition is most often seen pacing the staircases, perhaps reliving the emotional battle she faced while she contemplated her death. Those who have walked by the landing often report being overcome with strong feelings of anxiety and dread. Over the decades, that sense of dread has permeated the entire estate. According to *Ghosts Stories of Minnesota*, written by Gina Teel, the first recorded sighting of the maid happened in 1920. A young worker awoke in the middle of the night to find herself staring directly at a girl who was standing next to the bed. The spirit was described as having long black hair that fell over her white nightgown. The ghost attempted to reach out her hand to the woman, but before any contact could be made, the ghost vanished into thin air.

In 1939, the Shephard family donated the home to the St. Paul Gallery and School of Art. While most previous occupants fled the building every few years, the school somehow managed to survive until 1964. It was during this lengthy time that unexplained events were frequently experienced.

The entrance to the home.

Many of the students picked up on the uneasiness that seemed to ooze from the home's foundation. It was common for students to sense someone hovering over their shoulders as they worked on projects. Although there was an absence of visual sightings, the idea that spirits were present was never questioned.

In his book *Haunted Places*, Dennis William Hauck wrote of a former gardener named Charles Wade, who comes back from the grave to consult various gardening books that are shelved in the home's library. It was said that, while alive, Wade had kept the estate's lawns and gardens in impeccable shape. Wade's unrelenting need to keep the grounds in proper order seems to have superseded all other needs, including death.

The home has been the site of numerous paranormal events, but one of the more unusual was said to have taken place in the late 1950s. As one of the most infamous stories of the house, many different versions of it have been told through the years. The version I heard went like this. A former instructor at the school had moved away, freeing up his space as a rental for two college students. The spirits wasted no time in making their presences known to the new residents. It was during his first night inside the home

Séances were once held on a regular basis inside the home.

when one of the college students was awoken from a dead sleep. Rubbing the confusion from his eyes, the boy looked up to see the head of a little boy floating in midair. While at first glance the floating head story seems a bit far-fetched—even in a field that specializes in being far-fetched—I have been told by others that several additional floating heads have popped up in the course of the home's long history.

In 1964, the mansion was again put on the market when Carl Weschke decided to purchase the majestic home. Weschke was the owner of Llewellyn Publications, for which he wrote and published books on topics of the occult and supernatural. It seemed that the pairing of Weschke and the home was a match made in New Age heaven. Weschke had planned to use the house for both his home and offices. To help with the necessary changes, Weschke hired a few contractors to renovate the mansion. While working, many of the men reportedly spotted a shadowy figure roaming the upstairs hallways.

Weschke, a firm believer in the afterlife, was also privy to several unexplained events, including phantom footsteps treading across the halls, doors slamming shut on their own and a foreboding presence that seemed to permanently linger inside the home. At one point, Weschke even claimed to

have been tossed down a case of steps by an unseen spirit. Maybe the perfect match wasn't so perfect after all. Critics contend that Weschke created and embellished the stories to further the sales his books, yet the home was plagued with a ghostly reputation long before Weschke arrived. Could it have been that his open-mindedness and willingness to accept the home's legends summoned the activity like some metaphysical lighthouse? Or was Weschke essentially just another regular individual caught up in the ghostly turmoil that had been brewing inside the mansion since 1883?

In *Haunted Heartland*, author Michael Norman's detailed research uncovered numerous accounts of paranormal activity. Norman recounts the story of a housesitting college student whose favor for Weschke turned out to be a living nightmare. In 1965, police arrived at the Weschke residence and discovered a young man huddled tight in the corner of the room. Cautiously, the police approached the young man, unsure whether he posed a danger to them. Within a couple of steps, the police officers saw their answer. Nearly naked, the young man sat shivering, arms crossed. When questioned about the odd situation, the man repeated over and over that he had seen death. The police gathered up some blankets and wrapped the young man up as they transported him to the hospital, where he was deemed to be suffering from a deep shock. The horrors the young boy faced that night in the mansion have never been revealed.

In 1969, three *St. Paul Pioneer Press* newsmen challenged themselves to spend an entire night inside the mansion. On this eerie expedition, reporters Bill Farmer and Dan Giese were joined by photographer Flynn Ell. The trio wrote of their stay in the aptly titled article "Newsmen Spend Sleepless Night," featured in the *St. Paul Pioneer Press*. Upon arriving at the mansion, the three men, like so many people before them, began experiencing feelings of a general uneasiness as a cloud of dread slowly engulfed them. They set up in a top-floor room and waited for the spirits to show themselves.

They group didn't have to wait long; approximately one hour after passing the midnight witching hour, strange noises began to creep through the house. First came the sounds of heavy footsteps trudging down the halls, followed by the ever-creaking staircase steps located just outside their room. Each time a sound broke the silence, the men would trade unsuccessful attempts at discovering the cause. About 4:00 a.m., with the safety of sunlight just hours away, their frayed nerves could handle no more, and the men hastily gathered up their gear and hurried out of the house.

In 2010, I visited the home and spoke with the woman who has owned, and occupied, the home since 1982. During my tour, she expressed some healthy

The staircase haunted by a suicidal woman.

skepticism surrounding the home's haunted reputation. She believed that the haunted stories were created solely to sell more books for Carl Weschke. In 2007, the *St. Paul Pioneer Press* quoted her saying, "To live in a haunted house was good for business." Although she had heard many noises while living in the mansion, she always attributed them to some logical reason. Yet under all of her denials, she subtly hinted that there was certainly more to the story than she was letting on; just how much she had experienced will never be known.

THE TRAPPED GHOSTS OF HAMLINE UNIVERSITY

Hamline University prides itself on being Minnesota's oldest university—a distinction that it hopes will help to separate it from the education pack. However, those who venture to the campus also believe that Hamline is Minnesota's most haunted university. Legends of paranormal events normally take years to build and grow. The eerie stories are excitedly passed on from generation to generation until they become a core part of the places they describe. Some of the most exceptional cases of the paranormal are the ones that have withstood the test of time. They are the types of cases in which long periods of history have been plagued by accounts of ghosts and spirits. Hamline seems to contain the ideal mixture for a perfect mystifying legend; at the university, both history and ghosts are plentiful.

In 1854, Leonidas Lent Hamline, a bishop in the Methodist Church, donated funds to provide the Territory of Minnesota with a place for advanced learning. Following the school's original charter of finding a location on the Mississippi between the cities of St. Paul and Lake Pepin, the original home for the institution was located in Red Wing. Excited about the prospect of housing a university, the city pitched in $10,000 toward the cost of construction. For its opening year, over seventy eager students enrolled at Hamline. In 1861, the university's enrollment numbers plummeted. The cause for the drop in students came at the hands of the Civil War. With so many young men heeding the patriotic call to fight in the Civil War, the university was nearly deserted. The effects of the war were clearly visible

Hamline University's welcome sign.

in 1862: the university had no graduating class. The university was still in its infancy, and the loss of such high numbers of potential students struck the fledgling university hard. Within seven short years, the university's Red Wing doors would be shuttered.

With the closure of the Red Wing buildings, the university sought out new suitable locations on which rebuild. After an extensive search, a seventy-seven-acre site in St. Paul was chosen. Construction on the University Hall building began in 1873, but the project was not completed until the summer of 1880. The first day of class for the 113 students began on September 22, 1880. Every paranormal story coming out of Hollywood seems to be filled with heart-wrenching tragedy, and in 1883, Hamline University experienced its first. In 1883, the University Hall building had only been standing for a little over two years when a fire ravaged the structure, burning it to ashes. The one saving grace of the fire is that it did not result in any human casualties. Having already suffered through one closing of the university, immediate plans for construction on a new University Hall (now the haunted Old Main building) began.

The university was determined not to fail, and with the much-romanticized frontier grit and spirit the project was completed in under a year's time.

During the next few years, other buildings sporadically sprung up on the campus, including a library and gymnasium. In 1917, the university prepared for the country's involvement in World War I. With the depleted enrollment caused by the Civil War still in its memory, the university vigorously practiced military drills and trained women in first aid. When World War II began, it was initially thought to be detrimental to the university; however, the war turned out to be a bigger boon than Hamline could have ever predicted. Universities throughout the nation were flooded with freshly returned soldiers who were intent on taking advantage of the GI Bill of Rights, which promised to fund their college expenses.

In 1969, faced with the unappealing possibility of moving the university for a second time, a year-long study was conducted with the goal of ascertaining whether Hamline should remain in St. Paul. Upon completion of the study, the board of trustees voted unanimously to keep the university in St. Paul. Today, the well-respected university ranks high on many national academic lists for its dedication to higher learning. Of course, it also ranks high on numerous lists of haunted locations, thanks to the long history of unexplainable events that seem to be centered on three university buildings.

DREW HALL

The most bizarre and intriguing haunting at the university comes in the form of a spirit known as the "Hand of Drew Hall." In his article "Haunted Hamline," Daniel Campbell writes about the old legend that sprung from Drew Hall. The story takes us back to the 1960s, when students were still fascinated by the technology of the newly installed elevators. One student thought it would be amusing to extend his hand into the elevator just as it was about to close in order to trigger the safety mechanism that would reopen the doors. Regrettably, the young man decided to continue his practice of tempting fate, and fate soon caught up with him. One day, the student approached the elevator and stuck out his hand just like he had done countless other times. This time, though, when the hand was extended, the safety sensory failed to pick it up, and the heavy elevator doors squeezed shut, taking the boy's hand with them. Don't worry, the guy survived the ill-conceived incident, but according to legend his severed hand was never recovered. Now, late at night, dorm residents tell the story of the disembodied

Drew Hall, home to much paranormal activity.

The Drew Hall corridor in which the "Hand of Drew Hall" eternally searches for its missing body.

hand that still roams Drew Hall. Could it be that after all these years the Hand of Drew Hall has found a new source of entertainment? The spooky question may be answered in Campbell's article, which goes on to state that even today girls living inside Drew Hall tell creepy tales of unknown icy fingers gripping at their feet in the darkness of the night.

OLD MAIN (FORMERLY UNIVERSITY HALL)

Old Main was the very first building constructed on the campus, and during that time its halls composed the entire university, including classrooms, clerical offices and the library. Old Main is the oldest standing building on campus and is primarily used by the university administration. Today, the preserved building is listed on National Register of Historic Places, but during its lifetime the structure has undergone several major renovations. The first renovation took place in 1978 when standard repairs were conducted. In 1985, a fire tore through the building, causing over $10,000 in damages and resulting in yet another series of repairs. The most extensive upgrades occurred during October 1990 when workers began a $290,000 overhaul of the building. During this period, workers removed and rebuilt sections of the tower, provided new shingles and even added a new four-sided clock to the tower. In 1993, a final renovation saw the addition of an electric carillon that could not only ring the tower's bell but play music as well. These renovations may play an integral part in the hauntings of Old Main.

In my years of paranormal research, I have found that any type of renovation or remodeling often tends to spark increased paranormal activity. The cause of this apparent correlation is not known; however, one theory speculates that spirits, much like the living, become comfortable with their surroundings, and when these surroundings are altered, it displeases the spirits and triggers them into action.

One of the main areas of Old Main is the beautiful lecture area called Bridgman Hall. In years past, wonderful concerts drew hordes of adoring crowds to the hall. It is also inside this well-preserved room that witnesses have reported seeing the apparition of a phantom pianist. Not limited to the theatre, this spectral musician has been spotted in all areas of the building. The room also showcases a hanging picture of George Bridgman, who was an early president of Hamline. The dare circulating among the students is

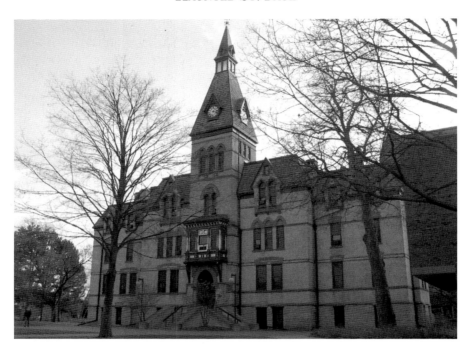

Old Main, the oldest standing building on campus.

that if you are brave enough to walk by the picture, the eyes of George will follow you as you pass. Some also believe that George's spirit is responsible for the playing of the piano, even though there is no evidence that George was in any way musically inclined. In her article "Believe It or Not: Ghosts Inhabit Hamline Campus," Elizabeth Garber writes that a security guard patrolling the area spotted a cloaked figure standing on the stage. The security guard thought that the figure bore a striking resemblance to the picture of George Bridgman. The guard was so terrified by what he had encountered that he immediately quit and went home.

I spoke with an employee who has worked inside Old Main for more than eleven years. This woman told me the story of an employee who may have got a little more than from his job than he had bargained for. The story involves a late-night maintenance worker who was busy performing his cleaning duties when a man wearing an old three-piece suit caught his eye. Initially, the worker believed that it was just another student walking down the stairs. It wasn't until the worker turned his head to a get closer look that he realized that what he had seen was not a regular student. What really stood out to the worker was the fact that the normal person who had

The Trapped Ghosts of Hamline University

The theatre inside of Old Main, where several cleaning workers have witnessed bizarre activity.

passed in front of him was not actually walking but floating. The witness was also baffled by the appearance of the man's suit and reported that it looked very old and terribly out of date. The sighting becomes even more bizarre when you consider that this floating man dressed in an out-of date suit had a noose dangling around his neck. Apparently, the worker was so terrified by his sighting that he fled the building and vowed never to return.

It should be noted that the maintenance worker is certainly not alone in his viewing of the mysteriously floating apparition. According to school legend, there was a hanging that took place in Old Main. Local lore states that back in the 1920s a distraught young student walked up to the bell tower of Old Main intent on ending his life. Slowly, he tied the noose tight around his neck, and with his last breath he fell to his waiting death. Like many legends of this kind, most of the important suicide details, including the student's name, have been lost to history. The one surviving crumb of information is that the when the young's man lifeless body was discovered, he was wearing his best three-piece brown suit. Since the 1920s, his floating ghost has been spotted countless times throughout Old

Main, and every time he is seen witnesses notice his brown, outdated three-piece suit.

Another spirit haunting Old Main begins with the tragic legend of the Drew sisters. The Drew sisters were said to be identical twins who attended the university many years ago. As twins, the girls were nearly inseparable and often claimed that they could experience each other's emotions and feelings. One day, while walking down the stairs to her class inside Old Main, one of the sisters lost her footing and tumbled down to her death. The accidental death was more than devastating for her twin sister, who quickly spiraled into a state of deep depression. Within a week, the pain of her lost sister became unbearable, and the surviving twin slit open her wrists in the hopes that death would reunite her with her sister.

Although it is a wonderfully macabre and hair-raising story, Amy Ward's article "Ghosts of Old Main" casts doubt on the story's credibility. Ward points out that university records show no enrollment of two sisters with the last name Drew. Furthermore, no accounts of the Old Main deaths were ever officially recorded. Before you close the door on the Drew sisters, you have to consider that it is quite possible that the names of the sisters may have gotten changed over the years of storytelling. I have encountered dozens of haunted cases in which the proper names of those involved had been misspelled, modified and even completely changed though the course of years of constant repeating. Also keep in mind that if these deaths did occur during the early days of Hamline, the university would probably not be too eager to loudly announce it. The negative publicity resulting from the death of two twin sisters would provide more than enough incentive to keep the story hidden. In the end, no one can tell you if Old Main is truly haunted; the best you can do is take the advice of those who work there and make sure to watch your back.

MANOR HALL

Nearly everyone on campus who I talked to about the ghosts of Hamline told me I that I absolutely had to check out Manor Hall. Even though I was well aware that college students have no hesitation talking about ghost stories, I was still a bit thrown off at the prevalence of Manor Hall's ghostly reputation. In my investigation, I was able to track down a former resident of

The Manor Hall sign.

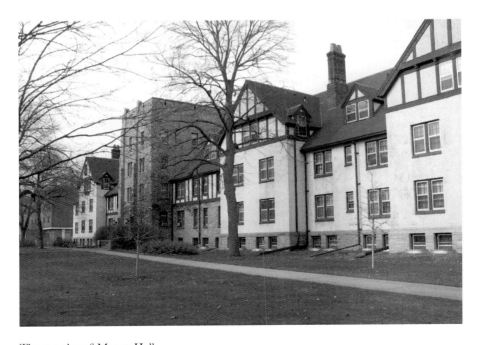

The exterior of Manor Hall.

Manor Hall who shared some of her bizarre experiences with me. She told me that, during one evening in 2000, she and her roommate were hanging out in their second-floor dorm room when they heard what sounded like a gun being fired, followed by a heavy thud, as though someone had fallen. Being a little startled by the odd noises, the two girls sat quietly and listened for any laughter or movements from above that could explain away the event. After a few moments of quiet, the girls decided to call security and request that they go upstairs to check on the people in the room above them. About a half-hour later, the security officers arrived to investigate the situation. When they were finished, they told the witnesses that they could not find anything out of the ordinary. Certain of what she had heard, the woman told me she just chalked it up to another weird story regarding Manor Hall.

The third floor of Manor Hall is also plentiful with spooky stories. It is on the third floor where many young women have encountered the presence of a playful spirit. Apparently, the mischievous spirit likes to move clothing and rearrange shoes. Other residents have given up on finding missing objects like their keys and phones only to discover them hidden in the oddest of places. To this day, the identity of the prankster ghost remains unknown.

If the abovementioned spirits did not satisfy your ghostly hunger, don't worry; the university has several more ghosts to appease even the most diligent ghost researcher. Among the plentiful miscellaneous university oddities is the "Pink Lady" that haunts the university theatre; buildings burdened by unexplained cold drafts; and a locked-off elevator in Sorin Hall that somehow operates of its own accord. With so many strange and bizarre events taking place at Hamline, it may truly be Minnesota's most haunted university.

DON'T LET YOUR ADVENTURE END HERE

Normally, when a book ends, you place it on the bookshelf, where it sits idle with other forgotten texts. I sincerely hope that this is not your goal for this book. Don't let the termination of these words end your adventure. Heed the advice from my introduction and set off on your own paranormal adventures. St. Paul is one weird place whose endless mysteries are just waiting to be discovered. No one on his deathbed ever said that he wished his life was less adventurous and exciting. Visit these places for yourself, and I guarantee that you will see some bizarre things, meet some odd people and hopefully along the way you might just discover that maybe you are a little stranger than you gave yourself credit for.

Keep an eye out!

P.S. I would love to hear the stories of your unusual adventures. Please feel free to contact me:

Chadlewis44@hotmail.com
www.unexplainedresearch.com